25
UNDER
25

TWENTY-FIVE UNDER TWENTY-FIVE

Edited by Iris Tillman Hill
Preface by Lauren Greenfield
Introduction by Tom Rankin

A Lyndhurst Book
In association with the Center for Documentary Studies

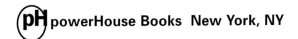 powerHouse Books New York, NY

Lauren greenfield
preface

A camera is a license to explore on your own terms. It provides a shield of protection, a mandate, a reason for being at a place, for looking, for participating. In normal life, you are not supposed to talk to strangers, or get too close to them, or stare. The camera affords freedom from social prohibitions, and is a passport for the journey.

Growing up shy, I remember walking the streets of Boston talking to strangers and making pictures for a photography class when I was a sophomore at Harvard. The camera was a way to break through my fears and learn about the unknown, the exotic, the other. I photographed places at night where I would not normally dare to go. A goody-goody who usually bowed to convention, I photographed rebellious punk rockers. A modest girl uncomfortable with my own body, I made a nude self-portrait in one of the public rooms of my college (when no one was there). Photography allowed me to explore the world, and test my own boundaries.

Having been raised by very liberal parents, I began photographing Republican conventions. I wanted to learn about the lives I hadn't lived, worlds that were not my own. When I brought my pictures back to class, Christopher James, my teacher, told me he had learned as much about me as he had about Republicans. This comment stunned and puzzled me, because in my mind I was bringing back another world. I was trying to show my classmates and teacher that old-school Republicans looked just like I imagined they would. That was obviously his point.

In the great documentary tradition, the photographers of *25 Under 25* are engaged in a journey for which the camera provides them license. The viewer feels their excitement at what they are capturing, and the raw energy of the process. In Colby Katz's image of a stripper with a man on the floor behind her go-go boots, one feels the rush of her discovery. The visible door frame references the photographer's presence and the viewer is struck by the immediacy and surprise of the scene she has come upon. Colby says she is especially drawn to eccentrics and special people. Misty Keasler, who made evocative color images from a Russian orphanage, describes her excitement at "walking into different and fantastic lives…real lives."

Diane Arbus, another photographer of eccentrics, once said, "If I were just curious, it would be very hard to say to someone, 'I want to come to your house and have you talk to me and tell me the story of your life.' I mean people are going to say, 'You're crazy.' Plus they're going to keep mightily guarded." The license is thus reciprocal. The camera invites the subject to let down his or her guard and be in relationship with the photographer as well. Many of these photographers integrate their feelings about the subject into the image. Unlike cinema verité's "fly on the wall" tradition, these photographers dance with subjects who are

willing participants. Eric Gottesman, with his mysterious pictures of anonymous HIV-positive Ethiopians, believes in collaboration to the point of giving his subjects "final cut," a practice that is anathema to photojournalists or anthropologists.

The photographers in *25 Under 25* approach their work from a personal point of view and ask us to experience the world through their eyes. Kristin Posehn brings us into a surreal landscape of amusement parks where people seem alone and disconnected and the quest for "amusement" takes on an absurdist quality. Andreanna Lynn Seymore presents intriguing photographs of people engaged in leisure activities who are similarly isolated yet surrounded by family and activity. Brian McKee's original portrayal of the former East Germany demands that we contemplate the discarded and decaying, the last remaining evidence of a people and a place that no longer exist.

In this collection of work, I am especially struck by the way many of the photographers use their photography to travel within as well as without. Their journeys are often internal, emotional, and consciously subjective. Laurel Nakadate's compellingly candid photographs of her friends' college parties give us intimate snapshots of a world to which she was drawn. Laurel says that her photography was not just the documentation of a surprising subculture, but an activity that actually lent stability to her life. Going beyond the role of camera as shield, photography is used by some of these photographers as a means of self-discovery and even as a therapeutic coping mechanism. Chana Warshauer-Baker documents her struggle with an eating disorder and what she calls "her own self-destruction." She explains that her eating disorder was connected to feeling out of control and not wanting to grow up. For her, photography was a way to become detached from her own experience, regain a sense of control, and stop time. To be in the room with Chana while she wrestles with her demons is a unique and moving experience.

Similarly, Carrie Levy bravely shares the unusual and heartrending experience of her father's incarceration. From the ages of fifteen to nineteen, she depended on her camera to mediate, understand, and cope with a devastating reality affecting her family.

These photographers have realized at a young age that they can mine rich material when they use their privileged access and personal perspective to take on subjects they are passionate about. It took me many years to come to this realization and return to my own culture. Once there, I could begin to question why I was drawn to certain themes in my photography and how my own explorations with the camera were related to my own particular upbringing and experience.

Susan Sontag said that "to photograph is to confer importance." The work of these photographers demonstrates not only the importance of what they are shooting, but of themselves, their ideas, their struggles, their lives. Their pictures prompt us to see what would otherwise not be noticed. Whether it is the indentation on the seat of a porch glider, plastic-covered living room furniture, the way dishrags are lined up in an orphanage, or one's own history or family, these photographers ask us to stop and take notice.

tom rankin
home and away at 25

I can look at stacks of photographs and never tire of where they take me and what they cause me to know. Particular images, certain groups of pictures, engage me more than others, but it almost seems I can look for a time at any photograph. Some turn me outward in unexpected ways, some bore me, and others remind me more of my own experience and move me from looking to remembering to reflecting. I have often pondered where this fascination with pictures comes from, but I sense it is rooted in my childhood.

When I was very young I would visit my grandparents and at midday was required to take a nap. My grandmother would take me up to her second-floor den, and I would climb onto a green upholstered daybed. Resisting sleep, I stared up at the wall above me which was covered in framed family photographs. Mostly portraits, formal and not, of members of my mother's family—including me and my siblings—the pictures stretched back several generations. Some were very small and round, others square or rectangular, none very big, but taken together, the wall offered a constellation of images that was at once familiar and altogether strange. The wall was populated by "my people," and as familiar as some of the faces seemed, others struck me as characters from a faraway place, strangers who crossed the wall above my head in fixed procession. Slowly I would lose my battle against sleep only to be roused an hour or so later, looking up again in a half-awake haze at the same ancestors through rested eyes. In those pictures I discovered stories, some told to me, others I dreamed or invented, stories so rich and faces so common that I know them to this day. The photographs came down over fifteen years ago, but my vision of that wall is so alive and fertile that it feels more present than past, and I've come to understand that these photos drew me to seeing as a way of knowing.

Some years later I began to make my own pictures, and on one project in my early twenties I photographed retired union coal miners in eastern Kentucky. One morning in Cumberland, I asked a retired miner if I could take his portrait and with his consent began to set up my 4x5 view camera, disappearing under the dark cloth to compose and focus. I had only recently started using a view camera and was nervous about the equipment but was also concerned about making my intentions clear to this very kind man. From under the dark cloth I heard the man ask simply, "What do you plan to do with this picture?" Immediately I felt the anxiety of not knowing the answer. Thinking quickly about what I hoped to do, I hesitantly answered, "I'm not exactly sure. I'm completing a project for a senior thesis at my college. I may exhibit these pictures, use them in school, I really don't know." My response was unpersuasive and offered without confidence. He didn't reply for a time and during the long pause I expected him to retract his consent. "It seems like a whole lot of waste of time and money to me," he at last asserted, still standing proud and looking straight into my lens, posed for his portrait.

His terse response was an accurate reflection of what he saw, but what he couldn't see and I couldn't say—because I didn't then understand—was that I had no choice but to take pictures. I didn't know what else to do. The twenty-five photographers included in this book, who were all twenty-five years old or younger when they made these pictures, probably don't know exactly what they plan to do with each image they make or why they search out certain subject matter and snap a series of pictures. Laurel Nakadate, whose "Girls' School" photographs appear in this book, understands this when she says, "I most admire those photographers who make pictures because they did not have any other options." The pictures in *25 Under 25* are made by young people with careful intent and discerning eyes, but I'm struck most by the inevitability of their work, the ways in which they are drawn to the medium and their subject matter as if there were no alternative.

Readers should look at the work of these photographers first, as it's their visual expression that is the feast spread before us, and only then go back to read each of their statements. Many of the photographers, we learn, began their experiments with photography at a very early age. With the vast democratization of the medium and the production of inexpensive and easy instamatic cameras, we can now imagine a near "cradle to grave" photographer, something hardly likely in earlier times. Colby Katz says, "When I was five my father gave me a Polaroid camera to keep me occupied." Misty Keasler began "making pictures with a Polaroid that I got on my seventh birthday." "When I was a child," says Jessica Ingram, "my mom gave me a 110 camera, and I took pictures of everything." The Polaroid photograph's instant image provided a tactile, interactive medium long before our oft-hyped internet interactions—it was not only something to "occupy" a child, but a way of framing the world that steadily evolved in the eyes of a child. "I became interested in photography on my tenth birthday," writes Carrie Levy, "when my mother handed me a blue-and-gold Fisher-Price 110mm camera with an oversized rewind button and black rubber grips." The ability to "rewind" experiences by looking at photographs you've made of your own life is at the root of photography's seduction, and these artists sat in the lap of visual expression at a very early age.

"The camera seems to me," wrote James Agee in the early pages of *Let Us Now Praise Famous Men*, "next to unassisted and weaponless consciousness, the central instrument of our time." When Agee published those words in 1941, they may have been more prophetic prose than a true reflection of the camera's place in society at the time. Knowing that these photographers cut their teeth on Polaroid and Fisher-Price cameras, and the little prints they produced, conjures an image of these "instruments" as central to learning, understanding, and expression. Hank Willis Thomas, whose mother is a photographer and historian of photographic expression, recalls "rampaging through family photo albums and rearranging pictures" when he was six, and then at

twelve making so many pictures that "we barely had the energy to look through them all." Growing up in the 1970s, all of these artists were confronted with more images than anyone could ever devour, much less digest, from ubiquitous still images to the centrality of television. Alex Ambrose's photograph of a Cambodian man "flipping TV channels to ease the boredom of an afternoon" is at once a moment from a particular culture and land, and an activity so familiar to her that it seemed profoundly universal. "The idiot box," my own father used to say about the television, chastising us for our fixed gaze, though ironically he watched it every night. The eyes that offer us these photographs have ingested images from all directions, morning, noon, and night.

Whether beginning their photography as young children or not, many of these twenty-five photographers were making pictures before what some faiths call the "age of accountability," a time when a child has enough perspective and wisdom to have their own vision and declare their own destiny. With a natural intuition, these photographers arrive at serious and deliberate image making. Nearly all of them have been "schooled," and many in some of the finest programs by the finest educators. Nonetheless, we can see in their work a freshness, a quality of picture making that is at once discerning and instinctive. Certainly we see the influences of their photographic ancestors, Lewis Hine, Walker Evans, Gordon Parks, Robert Frank, Danny Lyon, William Eggleston, Nan Goldin, Wendy Ewald, Reagan Louie, Carrie Mae Weems, Jim Dow, to name only a few. "The ancestral line," says W. H. Auden, "is not necessarily a straight or continuous one," making it difficult to locate precisely the wellspring of influences in any work. While we might recognize the conscious and unconscious results of photographic education, what engages me most is a freedom of seeing, a kind of reckless abandon that perhaps youth embraces best, when there's less of one's past work to measure current work against. To be sure, we find aesthetic formalism and a rich background of ideas conjured from education and study, but as vital and prescient are the threads twisted together from a thirst for exploration and reflection, investigation and personal association.

The more one knows about photography the more difficult it is to trust what you see in a photograph. These photographers, however, make no pretense that what they are showing us are "objective" images, that they are providing fundamental, irrefutable truths, that their work is somehow pure. Their trustworthy eyes come, in part, from the fact that they understand the subjectivity of what they do. Chana Warshauer-Baker, in her profoundly complex and moving essay "I Looked Like a Kid from Far Away," talks of photography as providing her "the illusion of control and objectivity." Like Warshauer-Baker, all of these photographers seem to understand how much the work is about them no matter what else it is about. Laurel Ptak speaks of her "double role as observer and participant" in her photographs of her family. Similarly, many of these artists recognize that they are both

within and outside their pictures, both the observer and the observed. They also, with humility and intuition, see, as Isabelle Lutterodt states, their role "to question, reassemble, and reassess the answers we have traditionally been given about ourselves." Their work, then, and their understanding of it, engages both the maker and the viewer in an ongoing discourse that does not so much drive toward resolution as it does toward understanding. For that, we trust the vision of these artists.

Where do these artists take us, what ideas do they confront us with, how do they shake us from our complacency? The geography of *25 Under 25* is vast and I suppose reflective of both the mobility of the photographer and of photography, a medium that's always traveled and in so doing taken us with it. But geography here can also be seen as where these artists come from, where they grew up and how, and the ways place defines their perspective. Andrew Rogers, from the Upland South city of Chattanooga, Tennessee, need not go far from either his youthful "tinkering with cars" or his home to discover his fascination with dirt track racing. Rogers describes these races as "a kind of feral ballet," a gas-powered choreography that he finds magnetic. Deirdre A. Scaggs, from nearby Kentucky, roots her images both close to home and far away, combining images of her own travels with cut-out pictures of her mother from family albums. Home and away from home, the interplay between the two at times obvious and articulate and at other times less visible and nearly muted, are measured against each other in the mind of the photographer. Andreanna Lynn Seymore, who grew up in New York, discovered an interest in photography "when I came across old family photographs and scrapbooks." While she does not necessarily photograph her literal "home," she reveals the complexities, the incongruity and ambiguity, of the community of family. Beginning with ideas of home and of family, she transports us into landscapes of association and fellowship that seem both familiar and ambiguously unsettling. Brett Myers, whose own family "lives within one half hour of each other," misses those he "strayed away" from. His most astounding portrait is of the indentation that remains in the seat of a porch glider in his subject's absence. In Jen Moon's photographic world, who along with Laurel Nakadate has roots in the heartland of Iowa, it's always night. She uses "empty sets to tell stories" that we narrate by our looking, searching for characters who have just left or preparing for their imminent arrival. These are empty but not entirely lonesome streets. The twenty-five come from all over the United States, both coasts, nearly every American region, cities large and small. Homeplace is often central to the story of their photography. However, just as often, their images are from halfway around the world, like Texas native Misty Keasler's pictures of a Russian orphanage. These travelers are navigating new frontiers in one way or another and are careful in their movements and in their representations of the worlds they visit. "I don't believe in traveling quickly through towns 'stealing images,'"

asserts Wyatt Gallery, a Philadelphian who has worked in the Caribbean. "I take my time." These photographers are wanderers all, moving outward to be fed by the confluence of their own and others' experiences, embracing, at different times, what Lucy Lippard calls a "multicentered sense of place."

How did we at the Center for Documentary Studies go about finding and choosing these twenty-five photographers? And once found, how did their pictures become a book? The process of locating and reviewing images is pretty straightforward. In 2000, we issued a call for slides of photographic work from artists who were twenty-five years old or younger on January 5, 2001. Over a hundred photographers responded, sending in slides of their photographs. We disseminated the call though a press release to papers and publications throughout the country and directly mailed the announcement to university photography programs, graduate and undergraduate, specifically asking photography educators to pass the word to students and former students. We posted the announcement on a select list of web sites. While we were in no way looking for only "documentary" photography, I am certain that many who read the announcement measured the style of their own work against what they thought the Center for Documentary Studies would find compelling. In that way we probably received a self-selecting group of photographers who, while not necessarily seeing themselves as documentarians (though some do), felt their work would get a sympathetic and understanding viewing here. An initial review of the submissions was done by faculty and staff at the Center, reducing the pool from over a hundred to around forty. At that point the book's editor began to work with the images to create this volume.

Like a photograph or an individual photographer's series of images, this book is the creative construction of a single editor, Iris Tillman Hill. And while she shared her ideas and took advantage of the perspectives of colleagues in photography and publishing, her vision resonates in this book, bringing the coherence necessary to achieve a fluid narrative within each photographic essay. She also worked to make them elements in a larger narrative, that of the entire book. Looking for both content and a formal freshness in the photographs submitted, and working closely with the photographers, she hoped to shape a visual essay that both reveals the particularities of an individual's photographic vision and also compels us to see the world differently.

This book, while not presenting documentary photography exclusively, is in a close conversation with the documentary tradition. Several of the artists have either studied or grounded their work within documentary image making. Kristin Posehn was a student at Duke University, taking courses in photography at the Center for Documentary Studies, which she remembers, "opened me up to a whole new way of seeing" as she pursued a project to document a Wal-Mart. Daniel Ramos stumbled into photography as a course of study in

Chicago, but eventually began to photograph his coworkers in a factory. His images are reminiscent of those of Lewis Hine and others drawn to photograph industrial workers, but they are also enormously different. These are Ramos's colleagues from his job in the same factory, not strangers he has met only long enough to make a picture. He is at once both a part of their world and distant and distinct from it, both a resident with them and a temporary visitor who has a camera and control over how they are represented in a photograph. Carrie Levy, who "found a comforting form of expression in documenting my family" is also an integral part of the community she photographs, a fact that bears witness to the gradual shift in documentary work from the simple outsider-documents-insider formula. In revealing her family's reactions to the incarceration of her father, she is participant in the family experience but also stands on the periphery, at least often enough to make the images we have the privilege to see. Her pictures intimately demonstrate the power of the artist—and of photography—to awaken us to fundamental societal truths through the particular life of one's own family.

Documentary photography has long included work that strives to remove barriers to understanding, to erase blind spots and collective amnesia, to shine light in dark places. Greg Halpern's images of workers at Harvard rest solidly in this tradition. Through his pictures and interviews and, most importantly, his own experience and understanding, Halpern wants to move others at a place like Harvard to see a community of workers for the first time and with deserved humanity. Eric Gottesman uses image making to address the impact of HIV in the lives of Ethiopians and hopes that his photography can "affect communities where the work is made." Pushing documentary toward collaboration and reciprocity, Gottesman's work recognizes and honors equally the roles of subject, viewer, and photographer. Aware of and participating in an ongoing dialogue with the documentary tradition, these young artists help us to better understand the promise of photography to narrate a diversity of stories.

Any photograph that contains even the slightest suggestion of human presence calls forth a narrative—the stories that such photographs tell may be fragments, may be the beginnings of longer tales, may be mundane or complex. These twenty-five photographic essays tell stories and take us on wondrous and sometimes troubling journeys. They use photographs to evoke places, emotions, and truths, and together, they form a larger, more complex and shifting narrative, like short chapters leading to an unforeseen ending. "I wanted to tell a story," says Jason Goodman about his photographs of Bangladeshi immigrants in New York City. Brian McKee sees his images as constituting "a mysterious and unnerving story from the not-so-distant past," a story found and told in Eastern Europe. "To me," says Bayeté Ross-Smith, "photography is about telling compelling stories. I create the setting and mood and leave the details to the viewer's imagination." These artists learned early that photographs have nearly as many meanings as they have viewers. They embrace that fluidity, understand the role of a viewer's imagination, and use it to deepen their message. As they fix their gaze on real, authentic places, on actual events and people, they understand what Andrew Rogers means when he talks of his early attraction to photography: "I loved the idea that you could create your own world with this fairly simple machine."

The worlds these photographers create are all about the human experience, whether in Russia or Tennessee. We see it in the faces of Justin Lively's subtle and considered portraits or in Kambui Olujimi's surprising look at women's football. Not one of these young artists is attracted to the unspoiled frontier, the nature preserve, the landscape that seems, even if untrue, to be untouched by human greed and culture. Perhaps this is because of, as the photographer Robert Adams has said, "the way we have damaged the country, from what appears to be our inability now to stop, and from the fact that few of us can any longer hope to own a piece of undisturbed land.… Unspoiled places sadden us because they are, in an important sense, no longer true." The truths here are about the terrains of home and heart, about both us and them, about places new and strange—home and away.

The young photographers in this book come to their work having thought about how the camera can be a weapon, about how careful one must be to make pictures that are honest and fair. "I wished no more to indict anybody," wrote Eudora Welty in the introduction to her 1971 book of photographs *One Time, One Place*, "to prove or disprove anything by my pictures, than I would have wished to do harm to the people in them, or have expected any harm from them to come to me." Like the twenty-five photographers here, Welty shared her nuanced, hopeful point of view: "my wish, indeed my continuing passion, would be not to point a finger in judgment but to part a curtain, that invisible shadow that falls between people, the veil of indifference to each other's presence, each other's wonder, each other's human plight." As a group, these photographers have a faith that their work can, as Misty Keasler asserts, dignify and give something back.

Welty was once asked to talk about her own vision, to explain her photographs and what they were about. "Well, I think it lies only in the work. It's not for me to say. I think it's what the work shows, comprises altogether.… I want the work to exist as the thing that answers every question about its doing. Not me saying what's in the work. In fact, I couldn't." And here, too, the work must have the final word.

contents

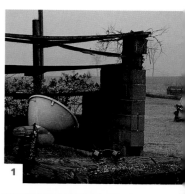

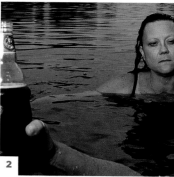

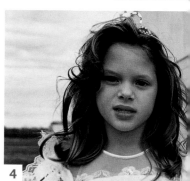

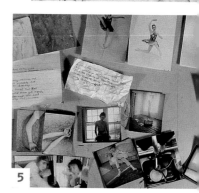

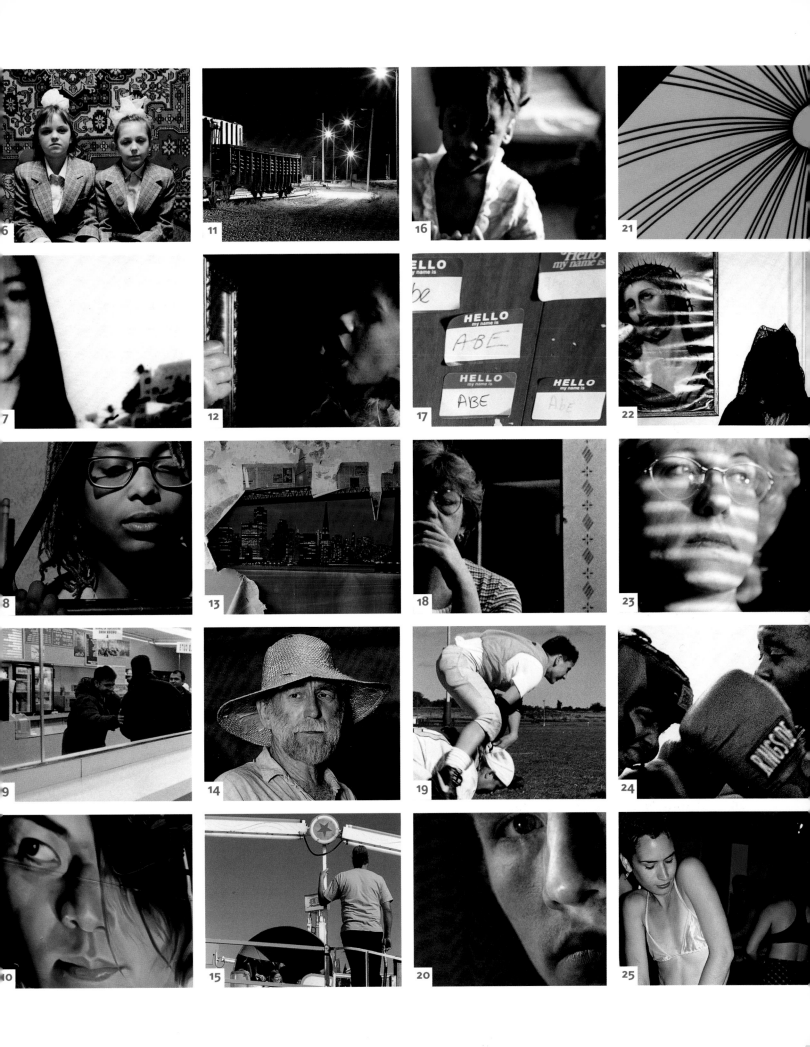

Andrew Rogers
Dirt Track

I bought my first camera on a whim when I was seventeen years old. I had no idea what to do with it, but I immediately fell in love with the way the world looked through the viewfinder, and later, the subtle little lies photographs could tell. I loved the idea that you could create your own world with this fairly simple machine.

For years I tinkered with cars. There was always an element of dissection and problem solving that engrossed me; it was the same with photographing at the dirt track. It was a way for me to deconstruct the races in order to understand them more thoroughly.

The races are full on—the noise is deafening, clouds of dust make you intermittently blind. You choke on the exhaust fumes from open headers, with their sickening and sweet smell. I think it's a perfect sport, and I was intrigued by the people. I wanted to convey the character of the race without actually showing the main event. I'm drawn to situations that are a little bit dangerous, a little bit uncomfortable. I try to convey this sense of unease, of things being on the verge of an explosion or disaster. Races are a controlled violent activity, and there are moments when they appear as a strange transfigured dance, a kind of feral ballet.

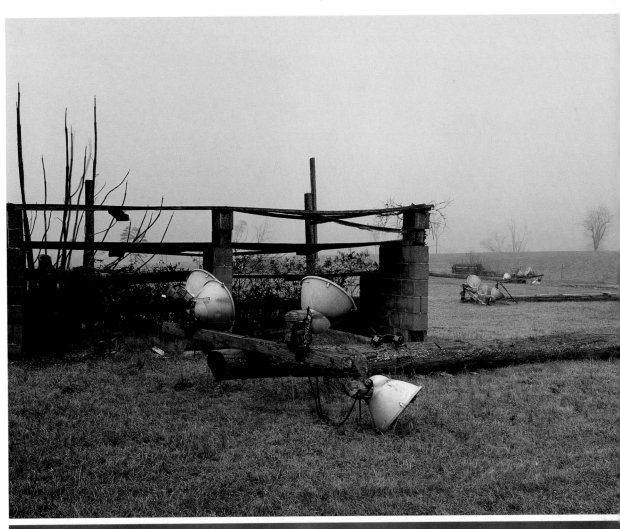

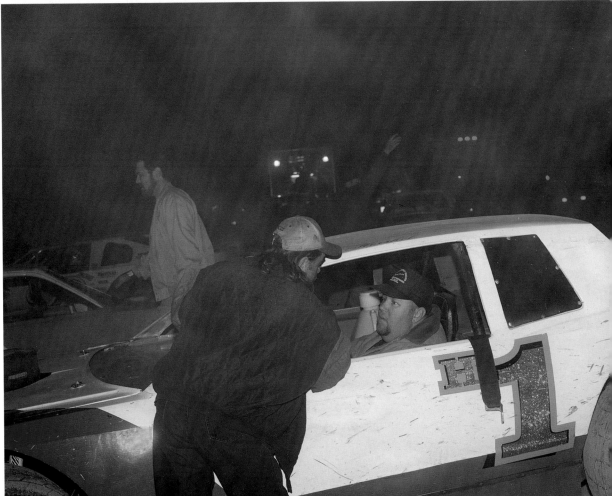

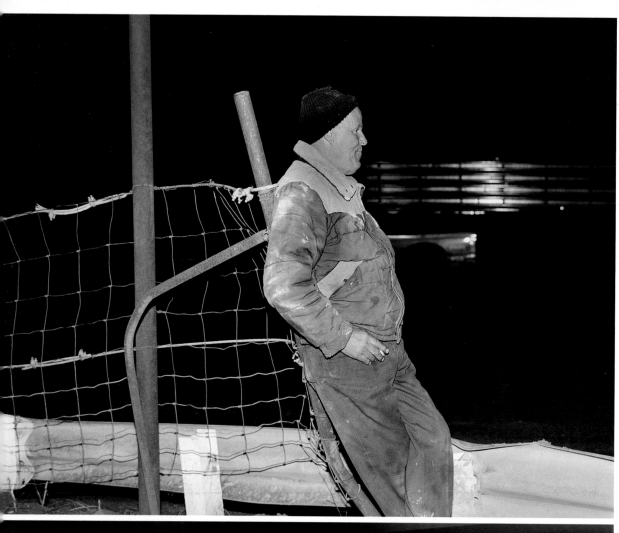

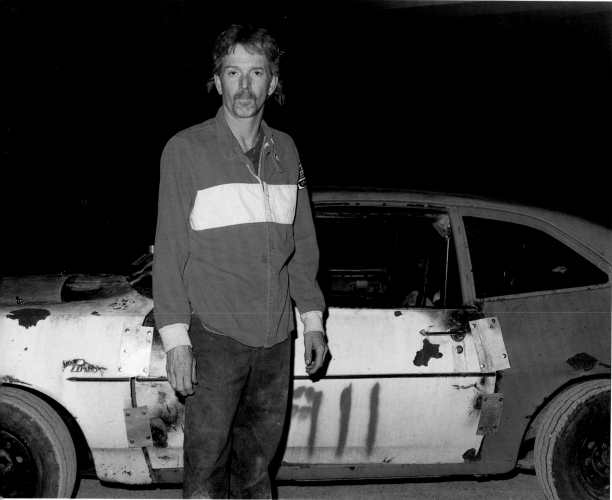

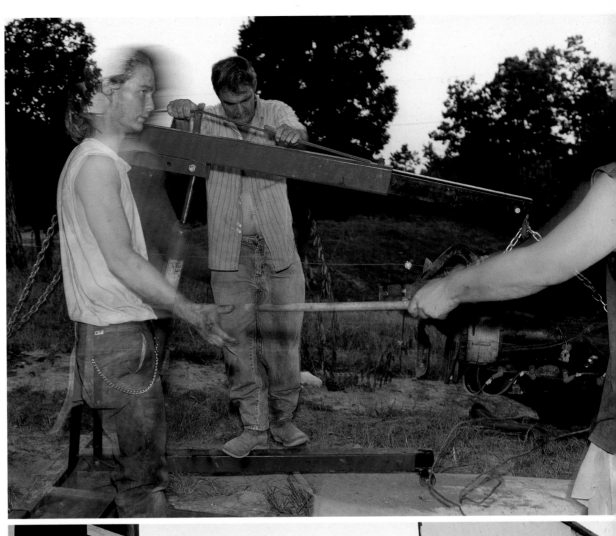

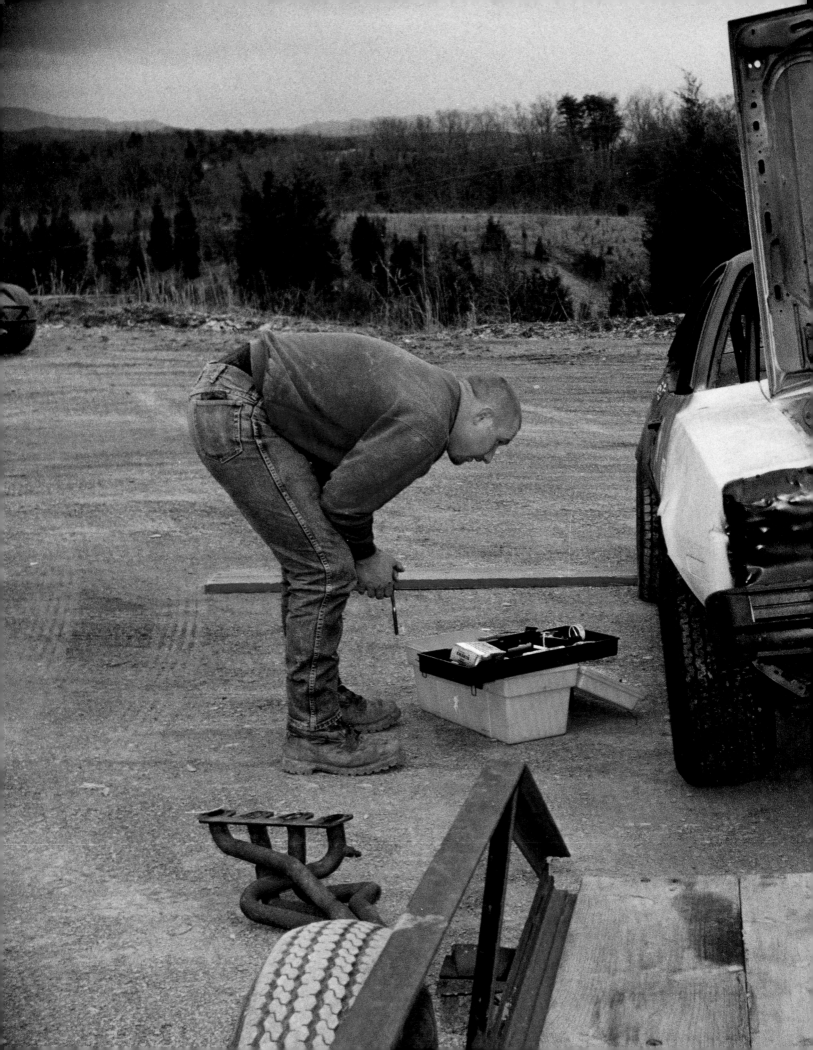

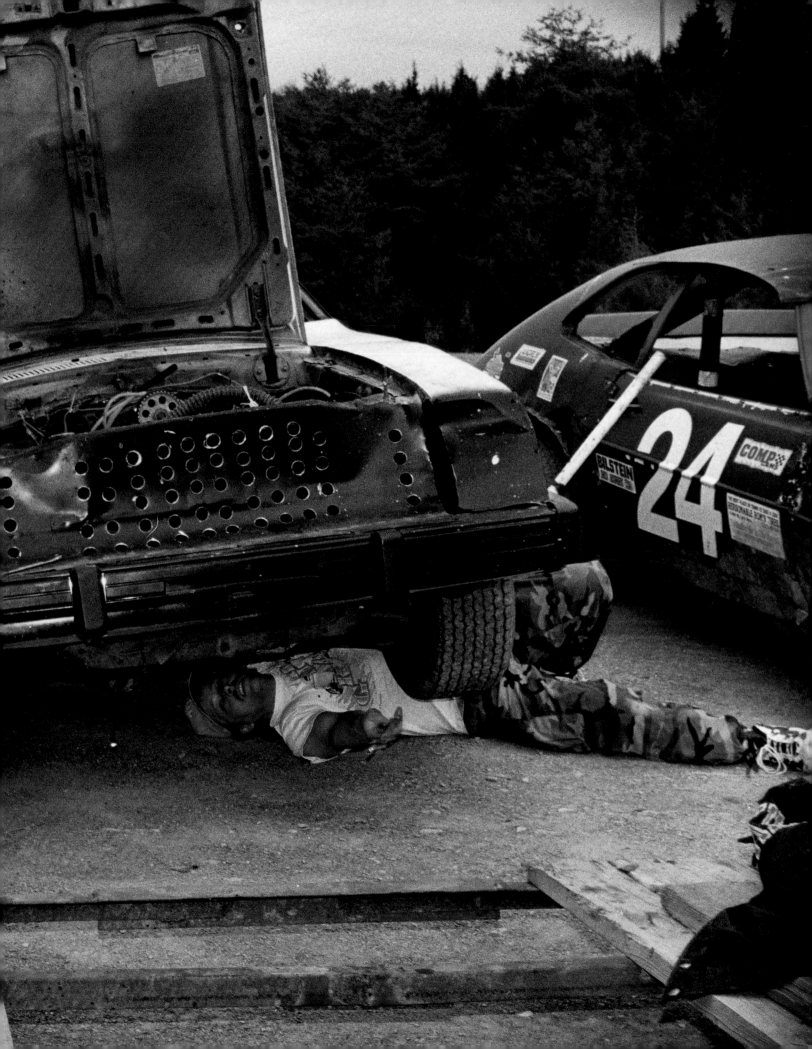

Andreanna Lynn Seymore
Cake and Hot Dogs

My interest in photography began in junior high school when I came across old family photographs and scrapbooks. It was like finding treasure. The books were stored in dirty boxes and had been forgotten for almost twenty-five years. My great-grandmother and grandmother, who were the family storytellers, had saved everything—photographs, cards, restaurant menus, remnants of first haircuts, my mother and her siblings' umbilical cords. I found it so interesting that these images and items told me a visual story of my mom's family.

The idea of family is important to me. I want to show the essence of family, and maybe not as we usually think of it, family as community. Some of these photographs show a Brooklyn family at backyard barbecues, visits with relatives, confirmation parties, and vacations. Others were made at Wild Women's Weekend, an annual, lakeside gathering of friends in Illinois that my aunt has attended for the last six years. It's a gathering for women only: no kids, no pets, no work, no husbands or boyfriends. And it, too, is like a family.

My images also often focus on the subtleties that make us Americans and that make American culture what it is. I try to give a sense of our culture without using the traditional patriotic icons. Instead, I look at simple things—gestures, painted fingernails, the small moments that go unnoticed.

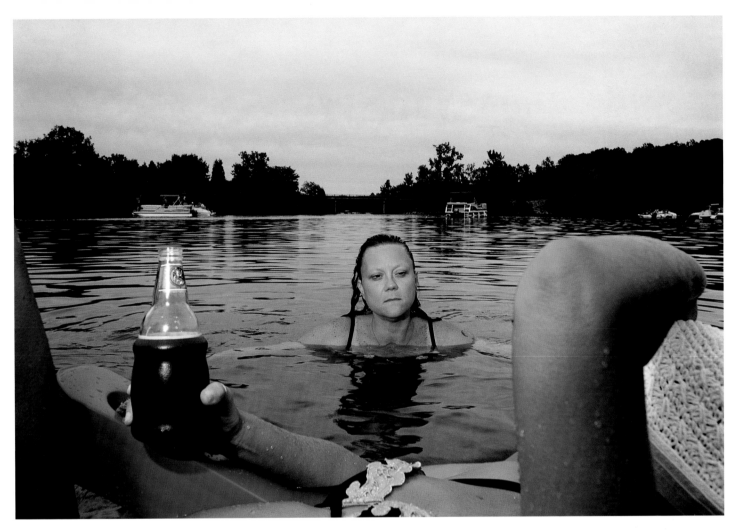
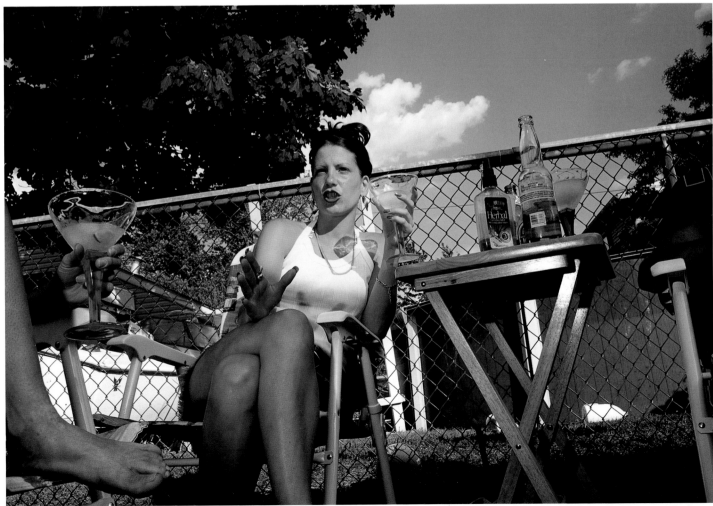

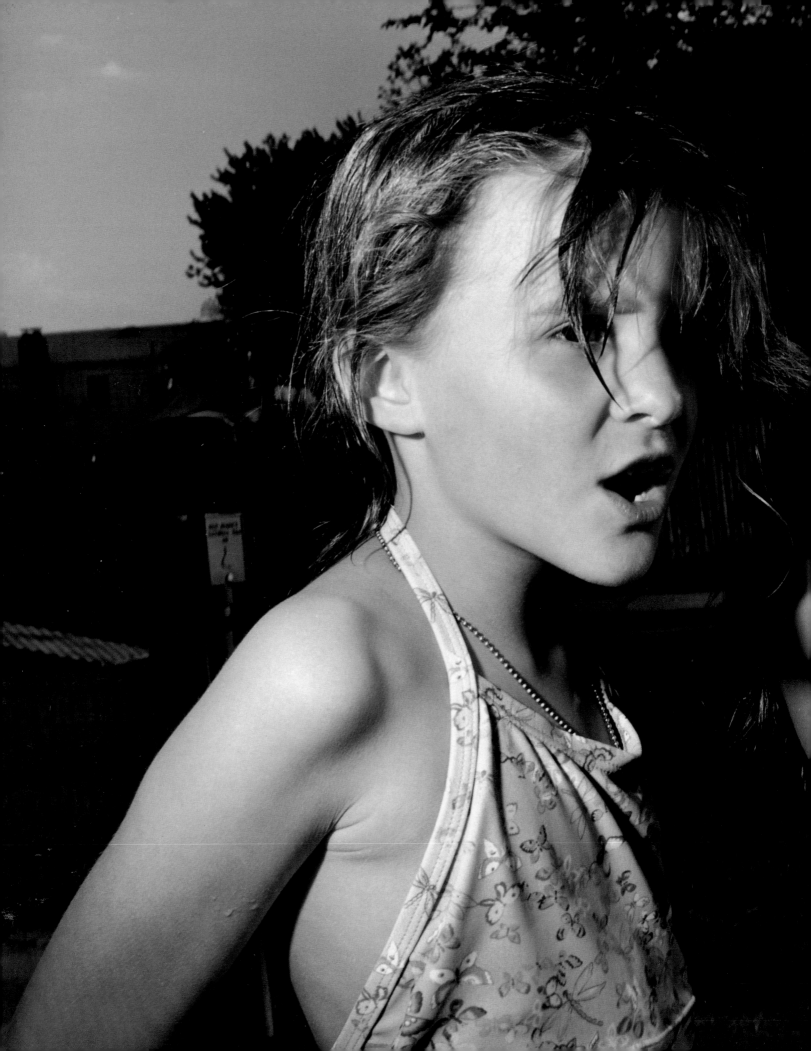

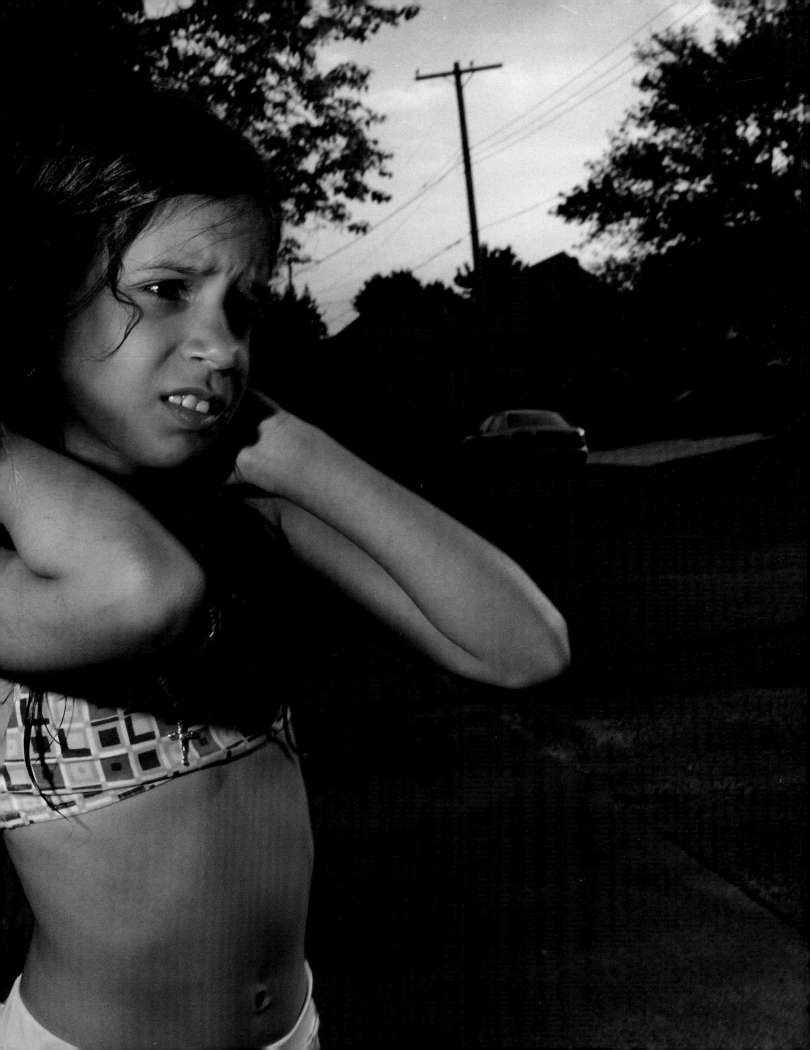

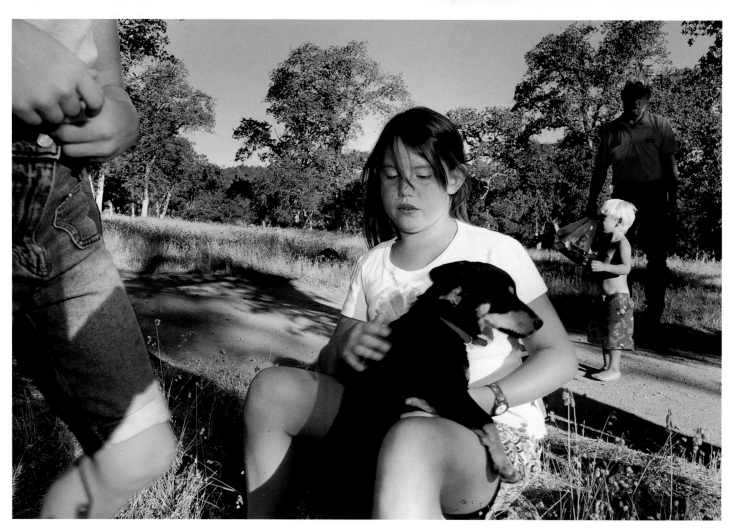

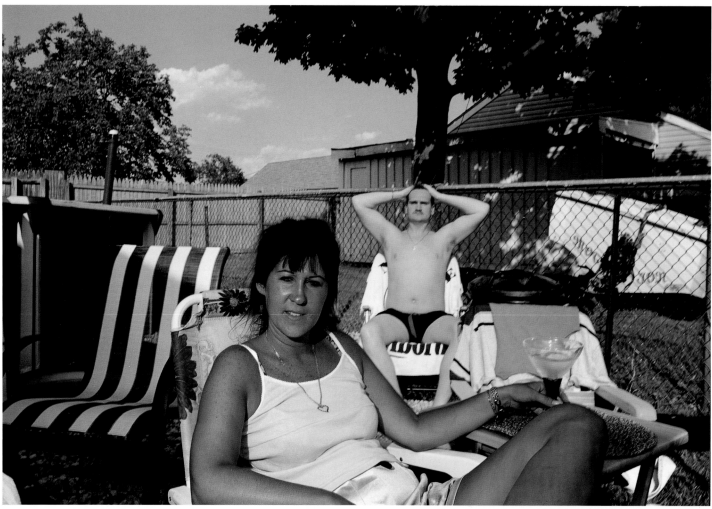

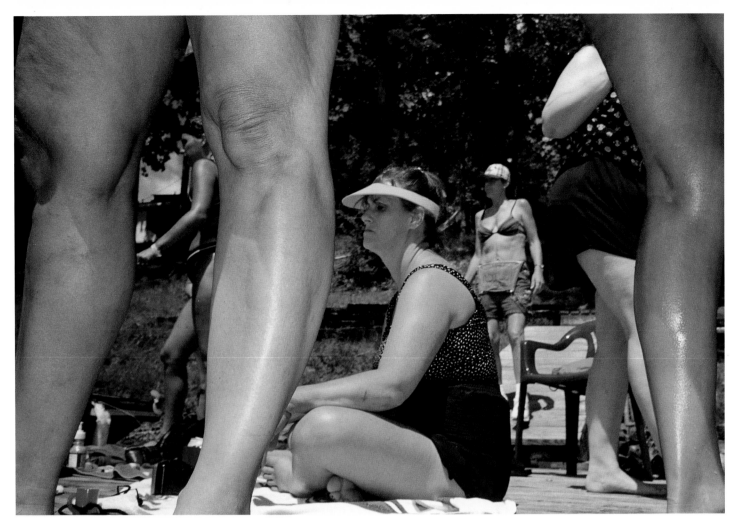

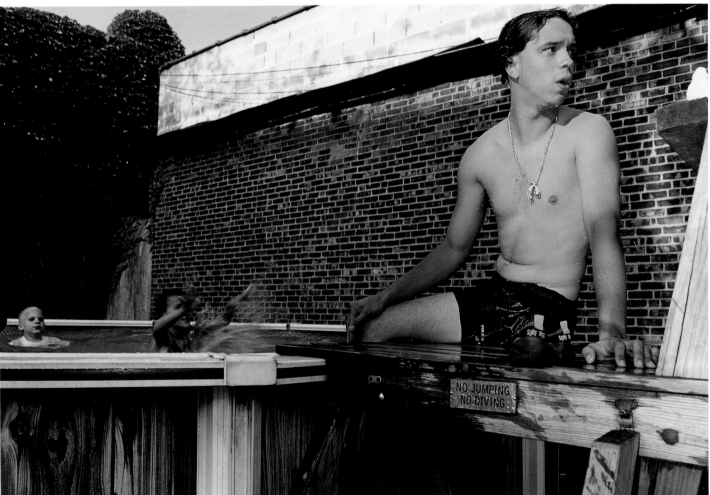

My parents came from Mexico, and after high school I went to Mexico for a year. When I came back, I worked at a liquor store, but my mother would bother me to return to school. One day my mother gave me ten dollars and said, "Today you are going to get on the train and go downtown, and you are going to come back a student." I knew I would get rejected, but on the train I remembered that Columbia College did not have an entrance exam but a "placement test." I headed there, took the test, and when the interviewer asked, "What do you want to major in?" I asked, "What you got?" When he came to photography, I said, "Stop! I'll take photography."

I did my project at the Sloan Valve factory because I wanted to show my teachers and the other students where I worked. I used a 4x5 camera and studio lights, and it was a big production to do this on the factory floor in the middle of the day while everyone was working. My father thought I was crazy when I decided to pursue my photography full-time. My friends at Sloan couldn't understand it either. No one at work believed in dreams anymore. I am a lucky person. I will never forget the day when I discovered that I could express everything that I felt and thought through pictures.

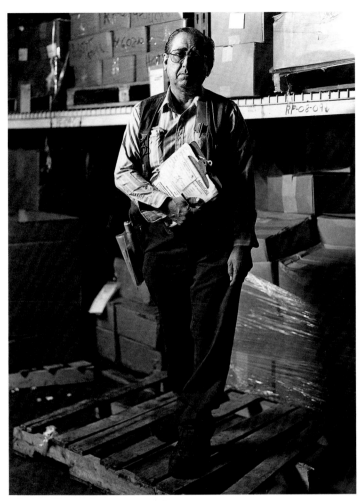
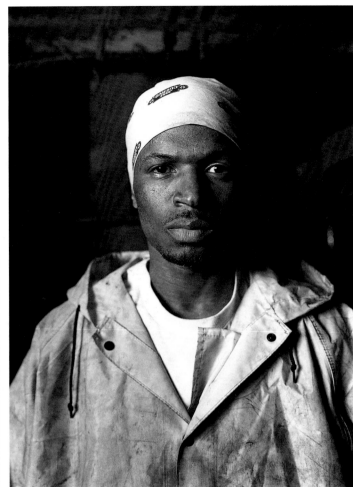
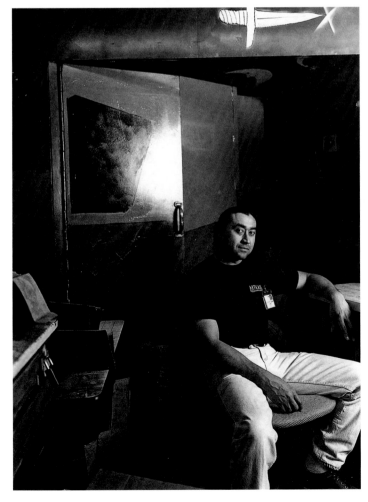
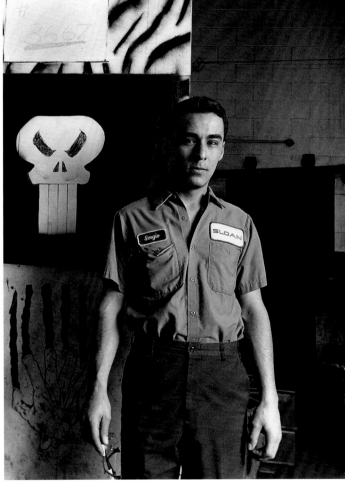

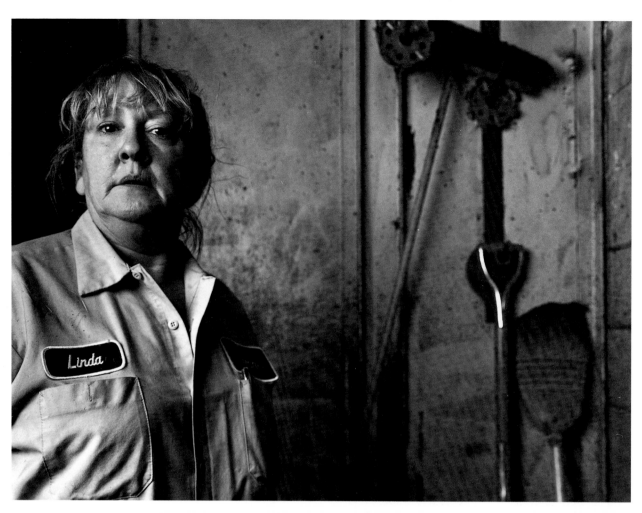

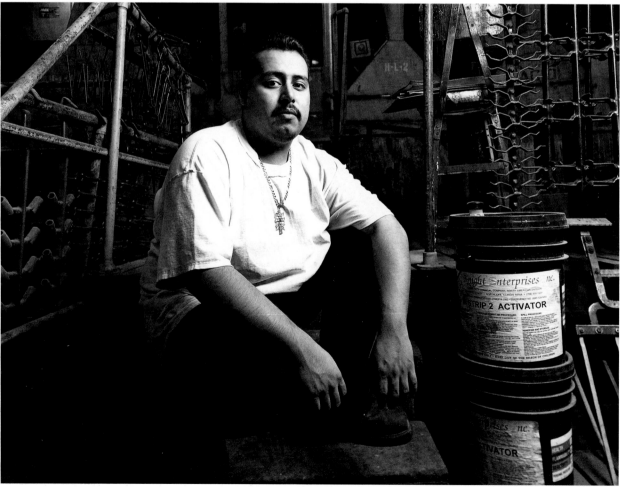

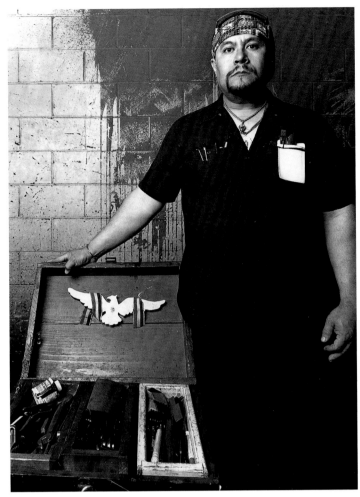

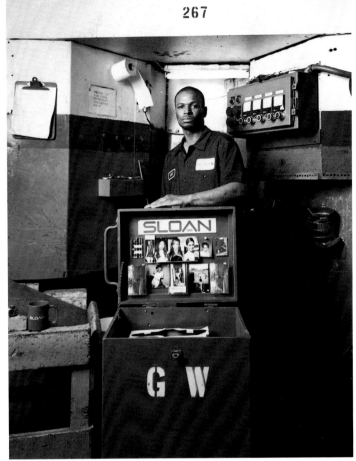

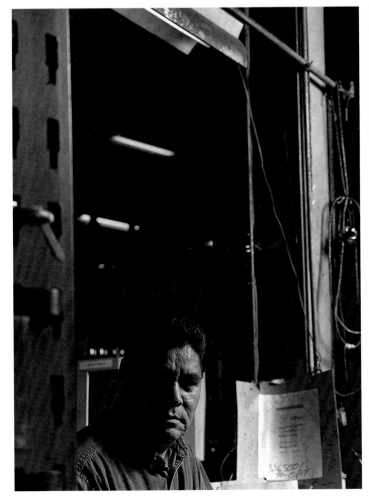

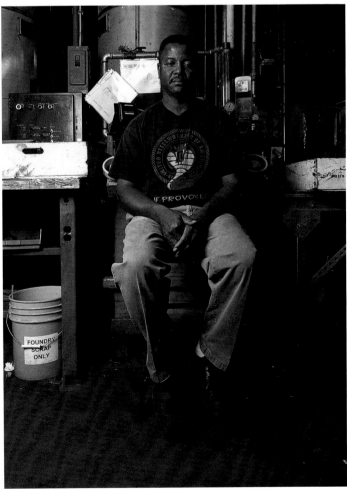

colby katz
miss All-star

When I was five my father gave me a Polaroid camera to keep me occupied. He didn't realize that I would break it within a few days and that he would be back at the store buying a new one. He was kind enough to keep replacing the cameras, and as a result I ended up falling in love with taking pictures.

I lived in New York City while I was finishing college and loved it. I found myself an apartment in a really bad area of the Bronx so that I could save my money to travel to small towns to shoot what I like. I am always on the lookout for special people. I photograph subjects that are close to me or interest me because of how they project their individuality. Sometimes I get too attached to them, and it becomes hard for me to keep taking their picture. People I believe to be eccentrics and visionaries are my heroes. This work is drawn from my photographs of women performers.

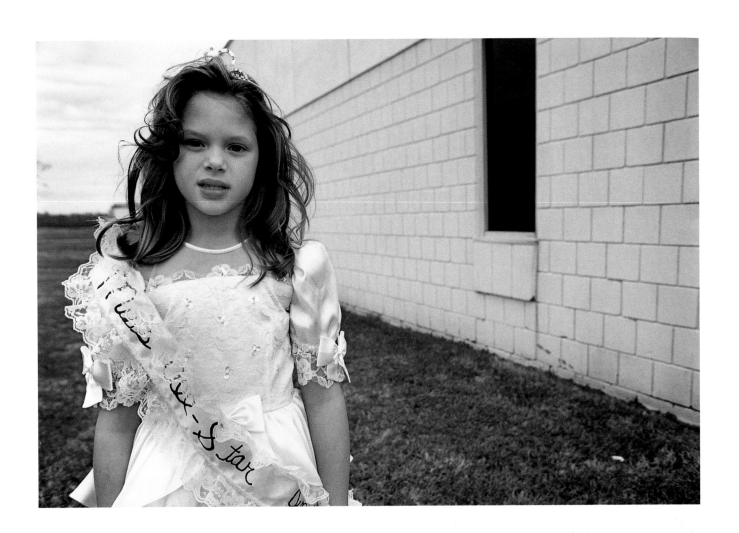

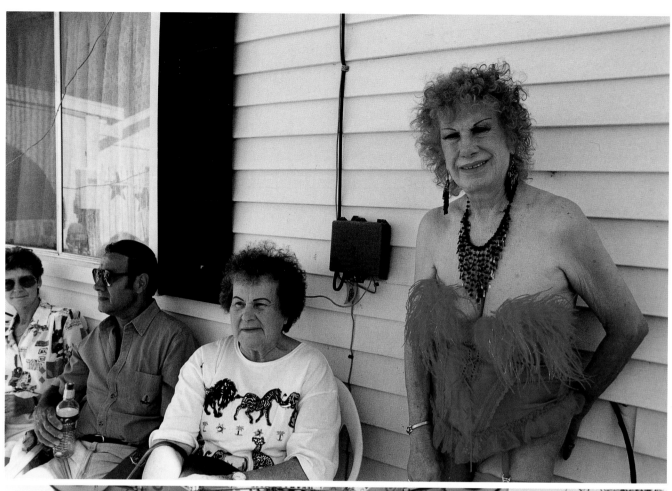
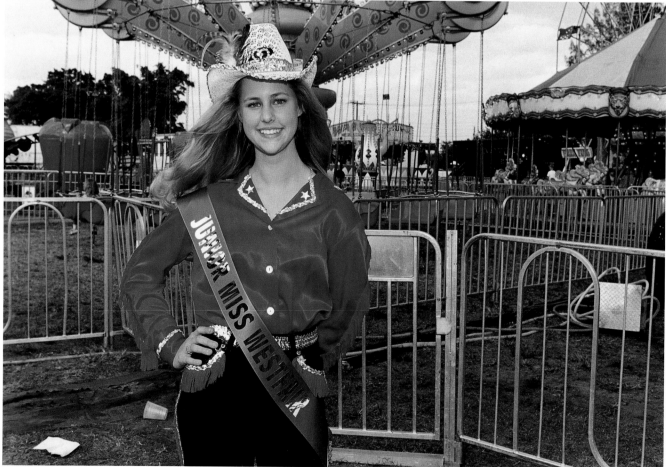

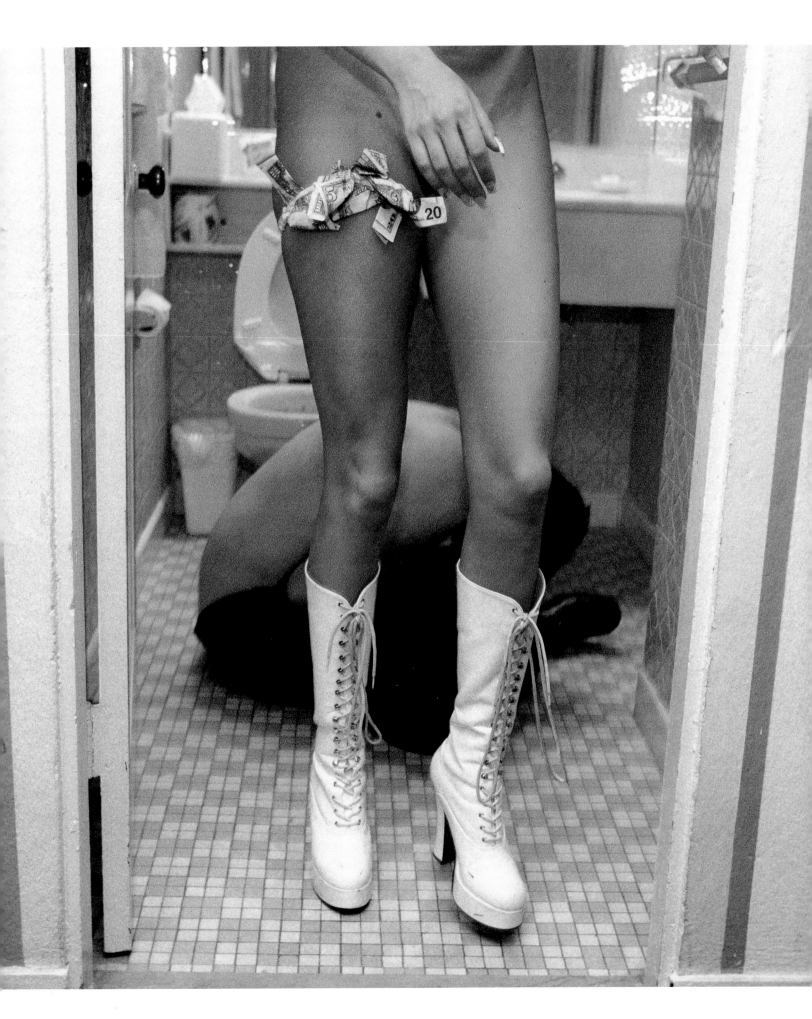

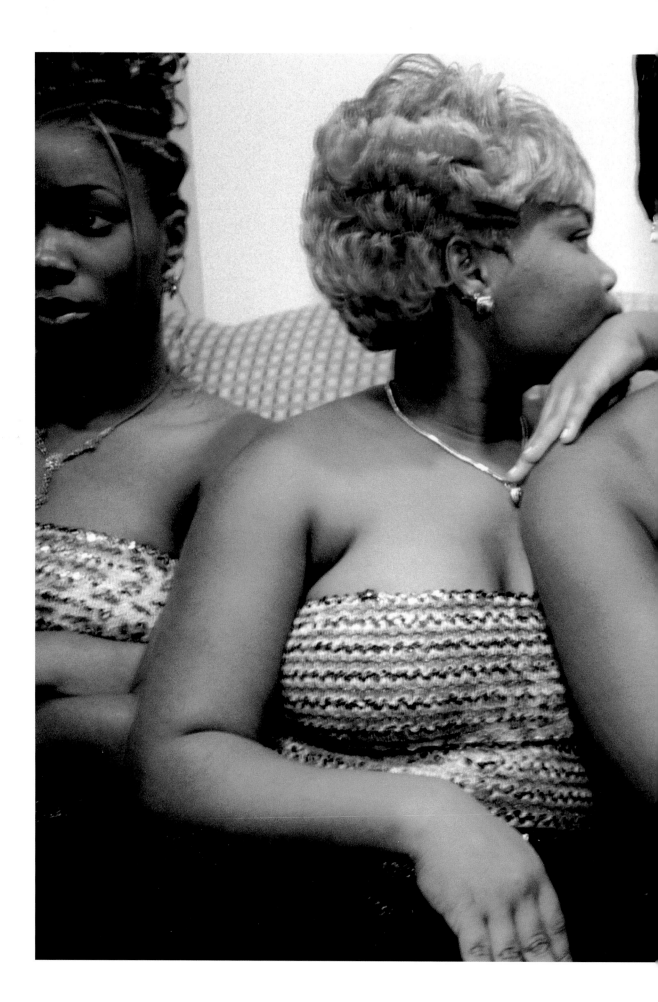

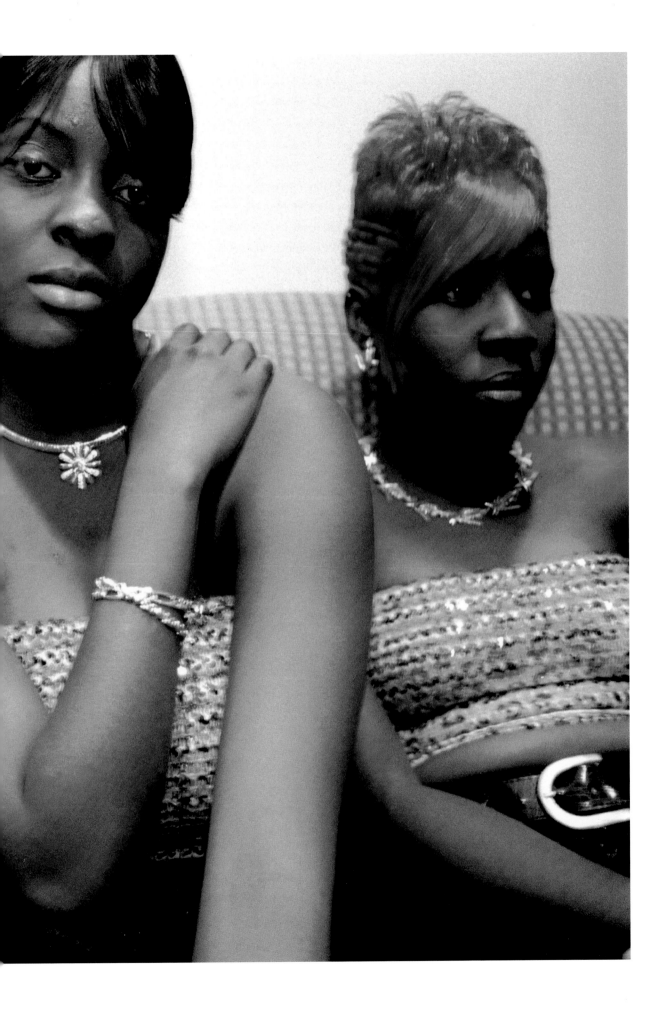

chana warshauer-вaker
ı Looked Like a кid from ғar аway

I made this series of photographs and writings because I wanted to speak about the cycle of self-obsessed self-destruction that had become my life. The act of photographing myself was a way to become removed or detached long enough to give myself the illusion of control and objectivity, or at least that I was making something. My photographs and writings were an attempt to make sense of what was going on. Maybe I wanted to aestheticize a very ugly experience that appears to be about beauty, but in truth, I believe, is more about a struggle for control and a fear of growing up.

(I put everything in a box to somehow contain it.)

"I Looked Like a Kid from Far Away" is dedicated to my family and friends who helped me get through this hard time in my life.

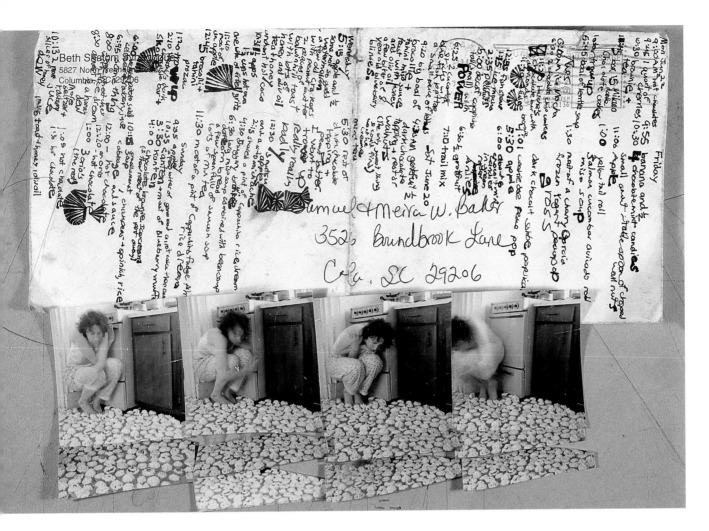

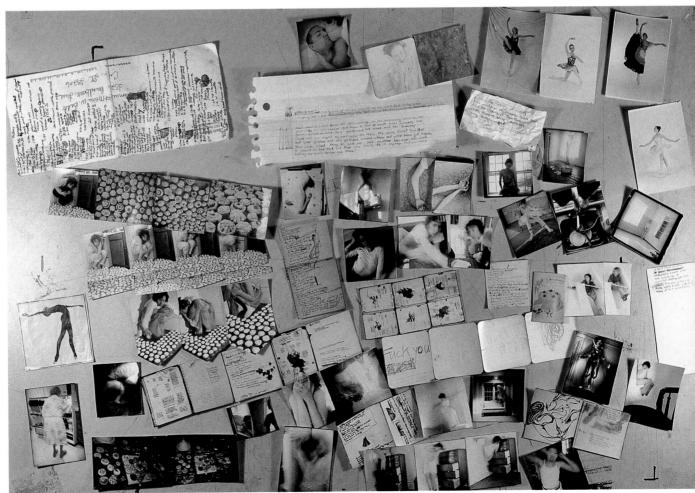

When Brian and I ~~Remember when~~ used to make out and we would tell me he could feel all the pain comming out of him. ~~And remember the time~~ And so we were having sex and he told me he had a crush on ~~a man~~ a girl in Texas.

Last week I called Brian and left a message on his answering mechine that said "Hey do you rember that time I had to meet your parents and your brother and his girlfriend. We went out for Sunday lunch and you heald my hand under the table the whole time? Your dad and your brother and his girlfriend ordered stake and your mom got keesh. Your mom cept tring to give me her muffen because she said it wasnt on her diet, but then she finally ate it anyway. And you were holding my hand under the table."

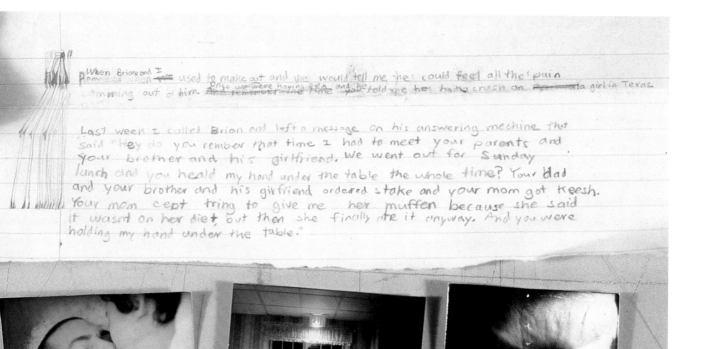

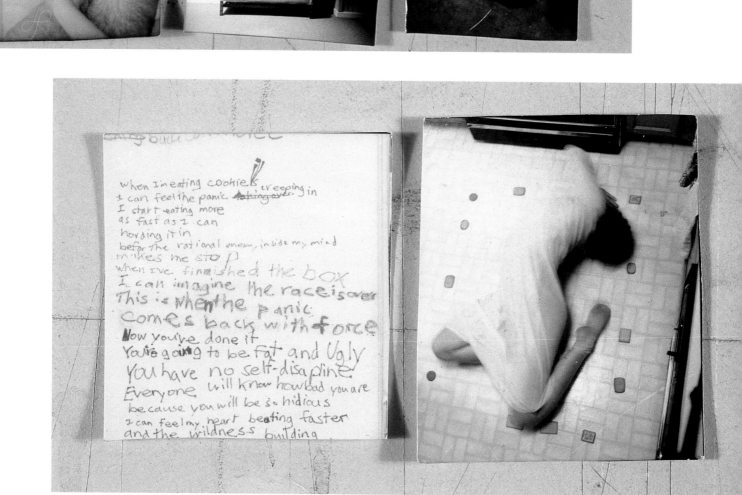

When Im eating cookies creeping in
I can feel the panic ~~taking over~~ in
I start eating more
as fast as I can
hording it in
befor the rational enemy, inside my mind
makes me stop
when Ive finnished the box
I can imagine the race is over
This is when the panic
comes back with force
Now you've done it
You're going to be fat and Ugly
You have no self-disapline
Everyone will know how bad you are
because you will be so hidious
I can feel my heart beating faster
and the wildness building

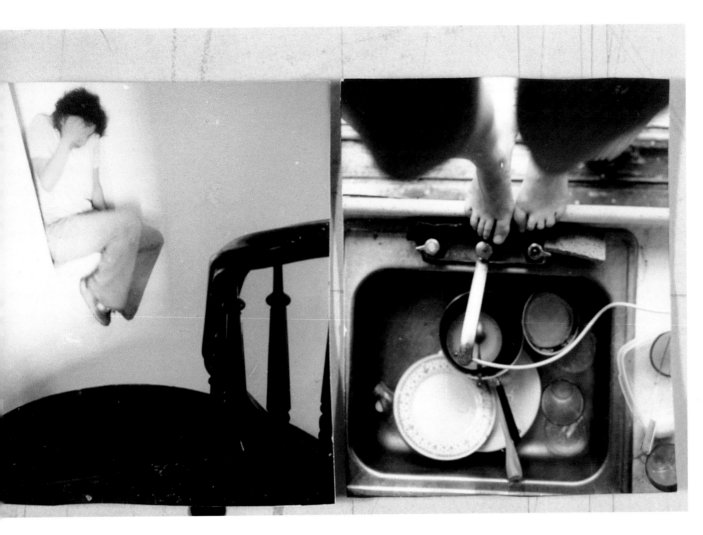

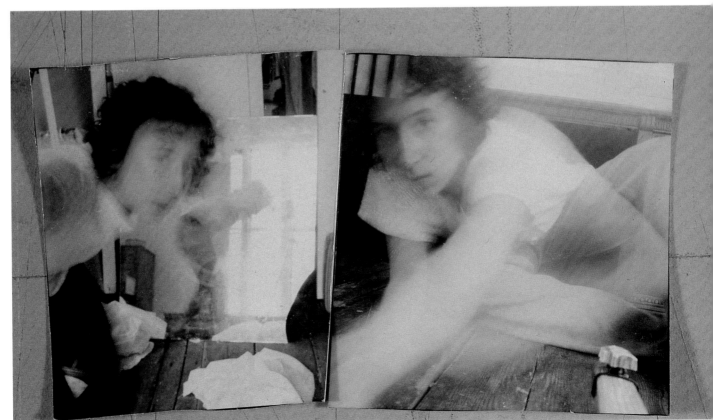

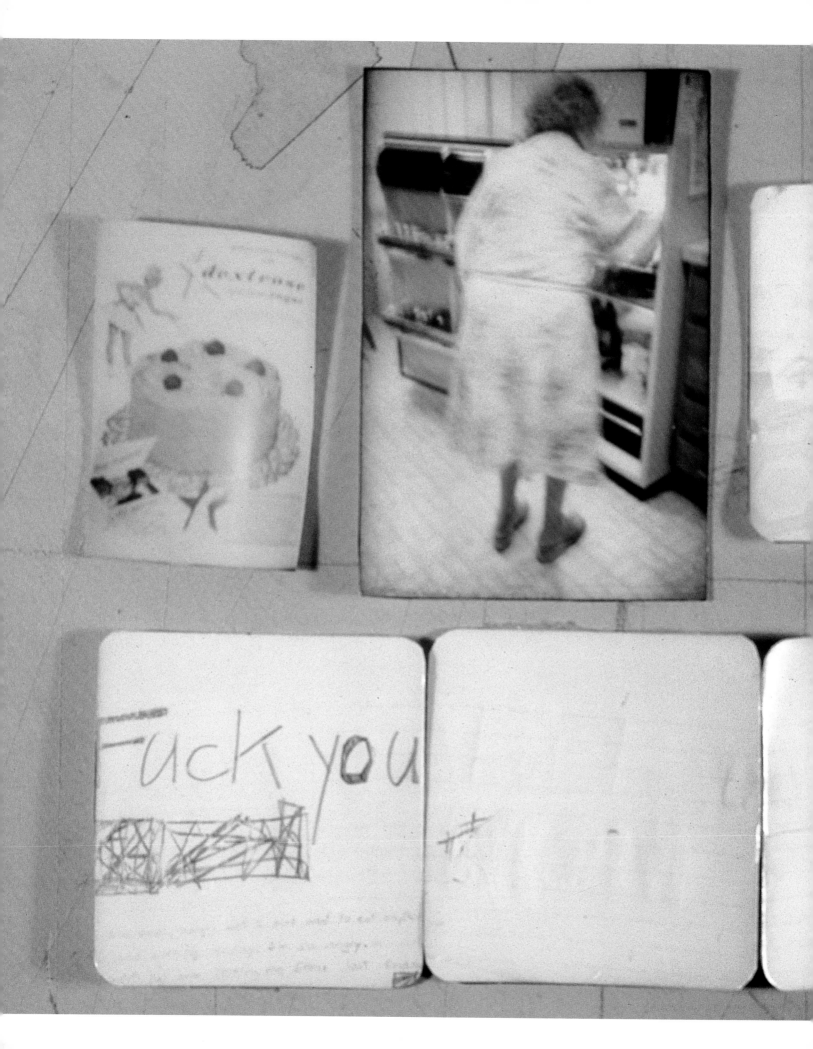

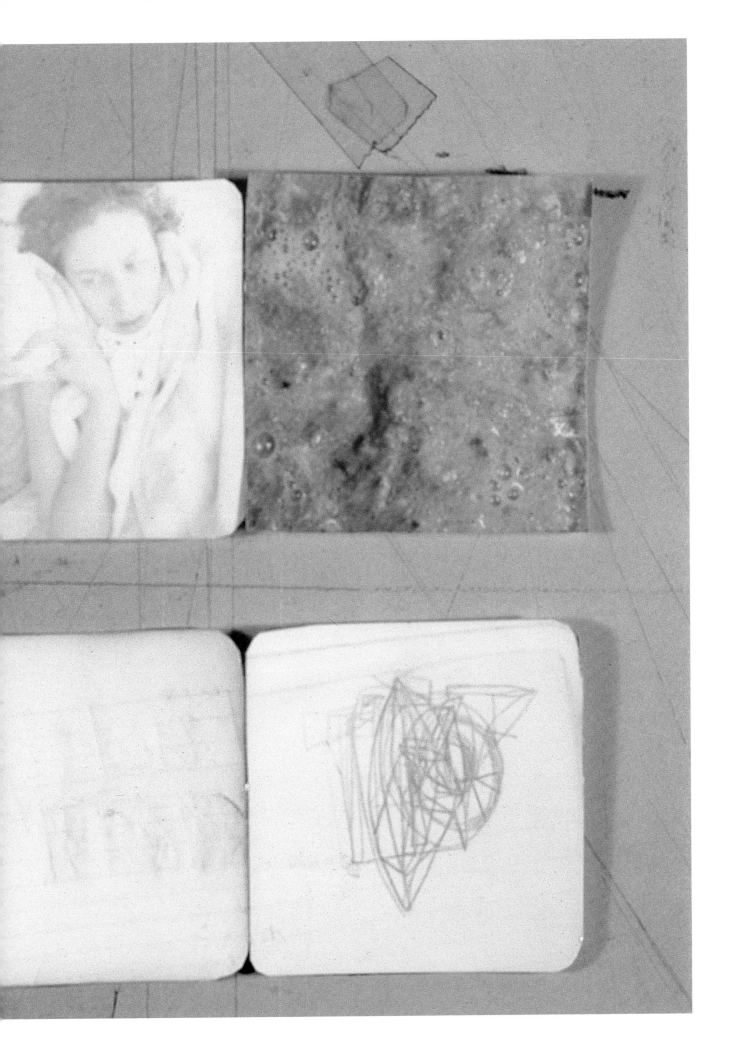

misty keasler
orphanage

I started making pictures with a Polaroid that I got on my seventh birthday. I come from a theater background, and what I loved about photography was the idea that, like theater, I could walk into and experience different and fantastic lives, only these were real, not stage, lives.

This project results from work I did in Russia with Buckner Orphan Care International. I left for Russia expecting to come home with images of orphanages as desolate, lonely places filled with hopelessness. Once there, I was struck by the quiet strength in the children, and the lonely images I had wanted to take suddenly seemed irrelevant.

I woke up one snowy morning in my hotel room and had a long cathartic cry. I was shooting innocent victims abandoned on doorsteps or to the Russian state. I felt that photographing them as victims would be exploitative and as horrible as the act of abandonment that had placed them in the orphanages. I wanted to shoot the children and their environments in a way that dignified them and gave them something back. I began shooting portraits in deep vibrant colors, and the children loved making the images. When you have a moment of human contact while making a picture, it is more intimate than touch or conversation. I really hated leaving them.

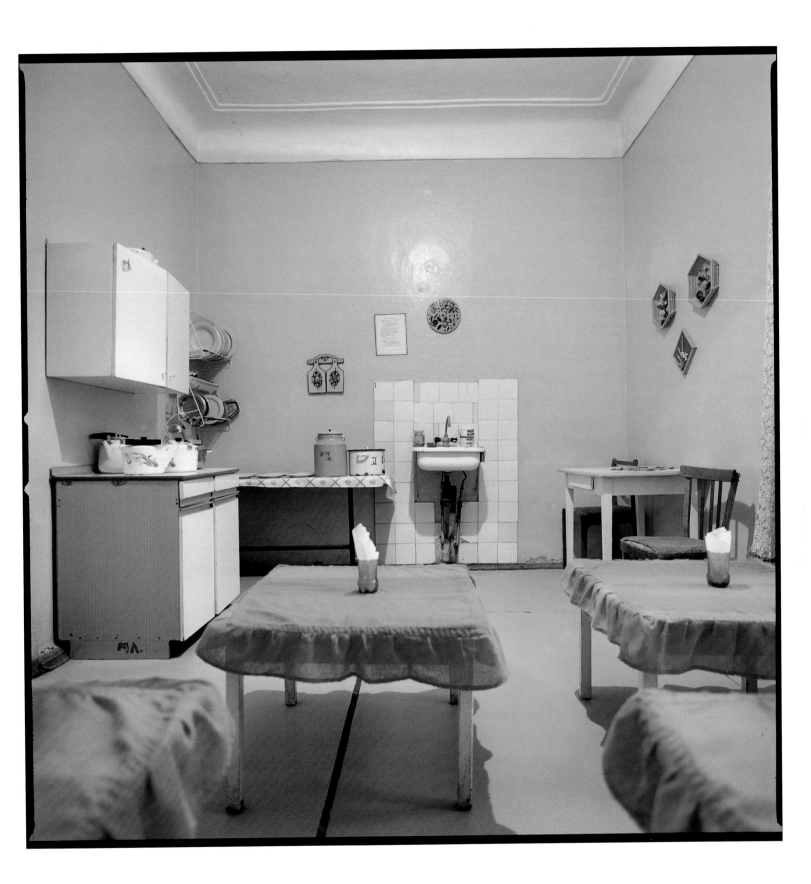

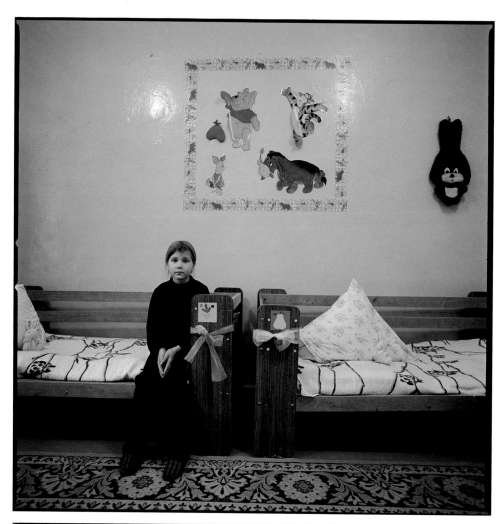

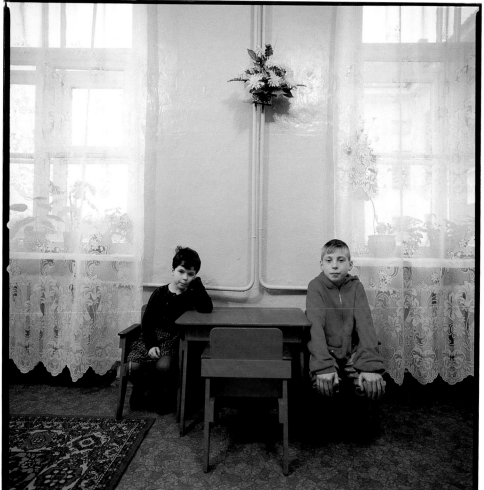

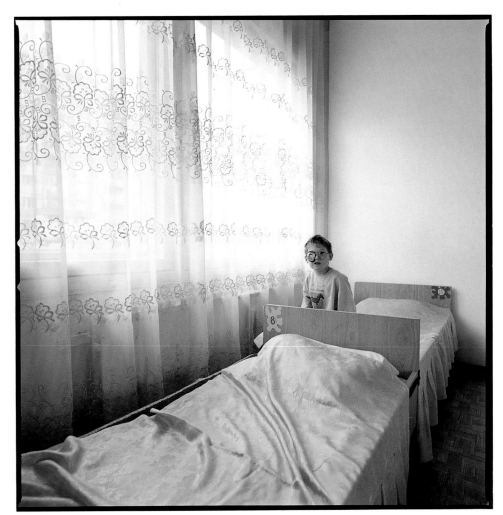

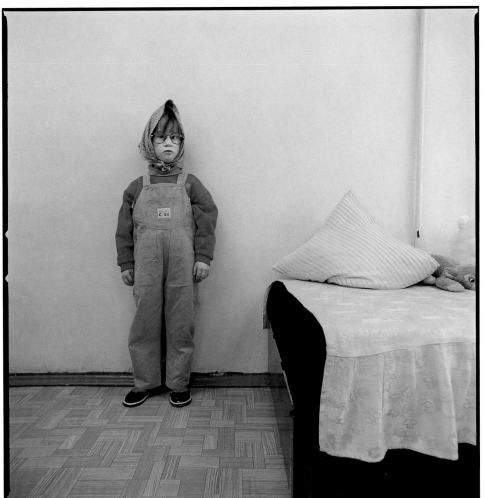

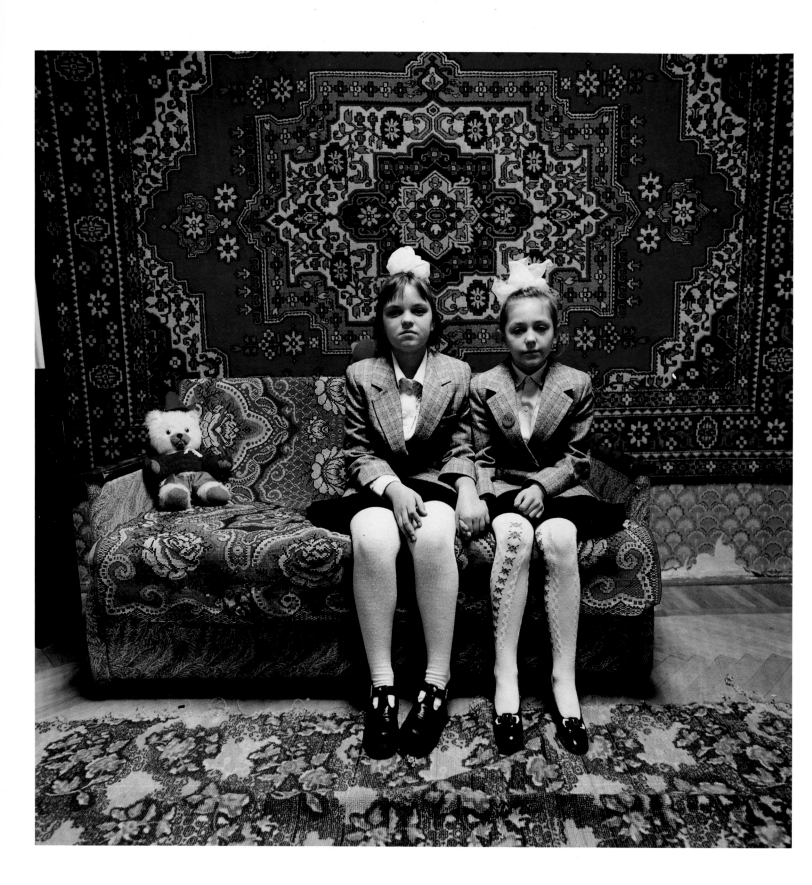

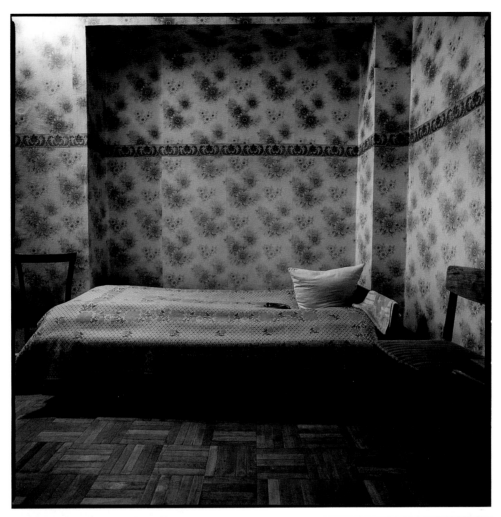

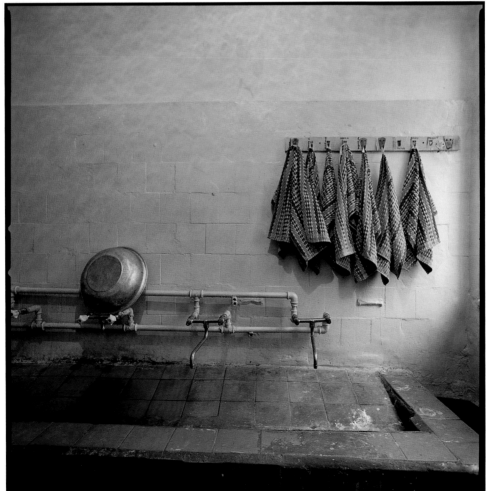

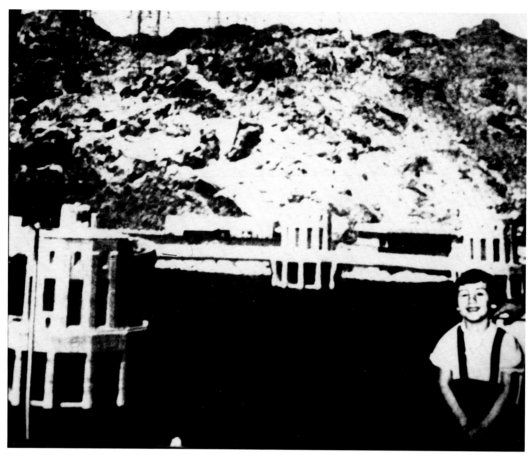

Hoover Dam. August 2, 1988.

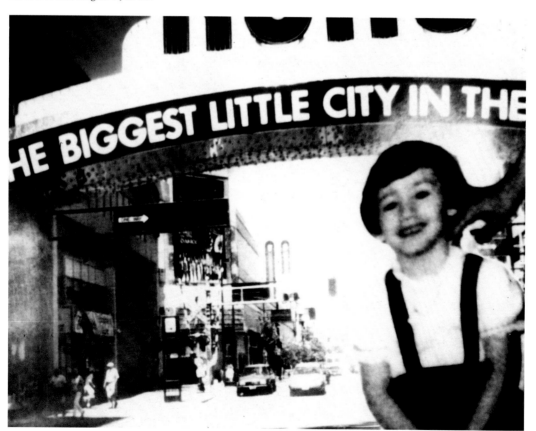

Reno, Nevada. March 21, 2000.

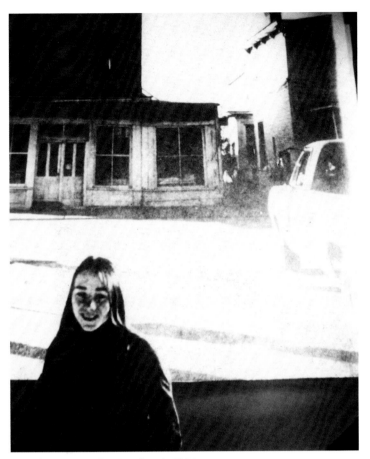

Vanceburg, Kentucky. October 4, 1996.

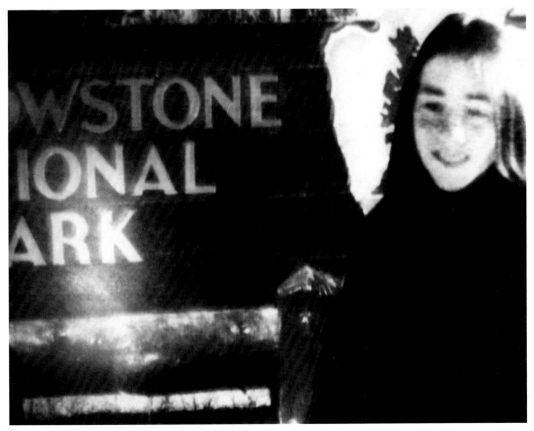

Yellowstone National Park. July 29, 1988.

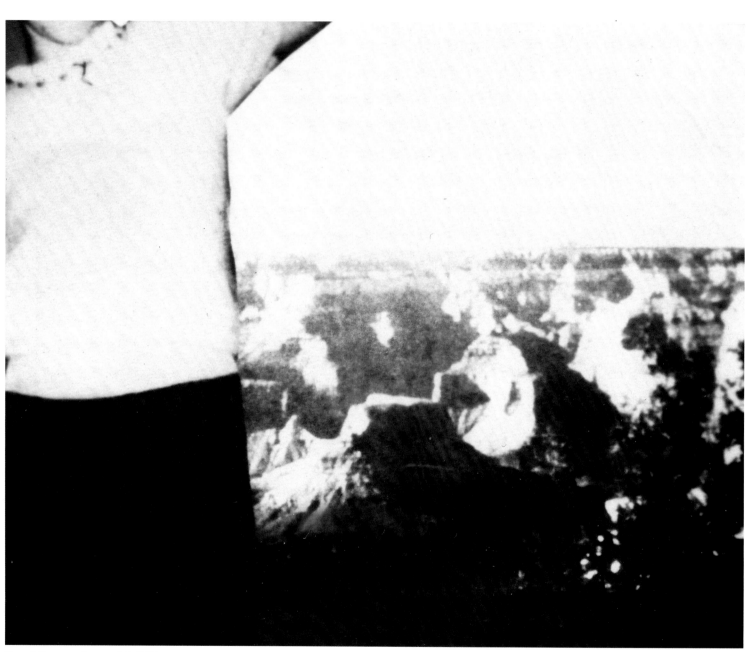

Grand Canyon. August 16, 1988.

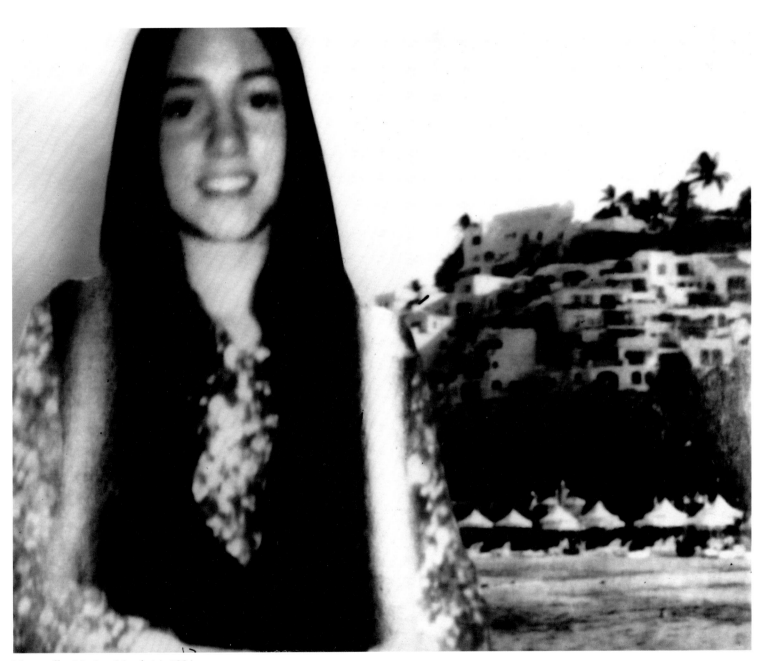

Manzanillo, Mexico. March 14, 1994.

HANK WILLIS THOMAS
REASON TO STARE

My life has been greatly influenced by both my parents' careers. My father has lived the most elaborate life, from being a soldier to a Black Panther to a physicist to a stockbroker to a real estate developer, among other things. My mother is a photographer and art historian who has dedicated her life to the history of African Americans in photography. Hence, I believe in exploration and redefinition. My mother's interest in photography was passed on to me at an early age—at six I was rampaging through family photo albums and rearranging pictures. At twelve I began taking pictures, burning so many rolls of film that we barely had the energy to look through them all. I recall my mother saying, "Hanky, don't stare. It's not polite." I could never accept that it was not OK to stare. Now I recognize that photography is a means to justify my addiction.

I want to use images as a way to question who we are and on what we base our aesthetics and moral judgments. There is so much to learn from the world by simply stopping and looking. Capturing moments in pictures is a way for me to share my thoughts. In my portraits, I try to create a conduit for viewers to connect on a sublime level with my subjects— as if looking in a mirror, or at someone they love.

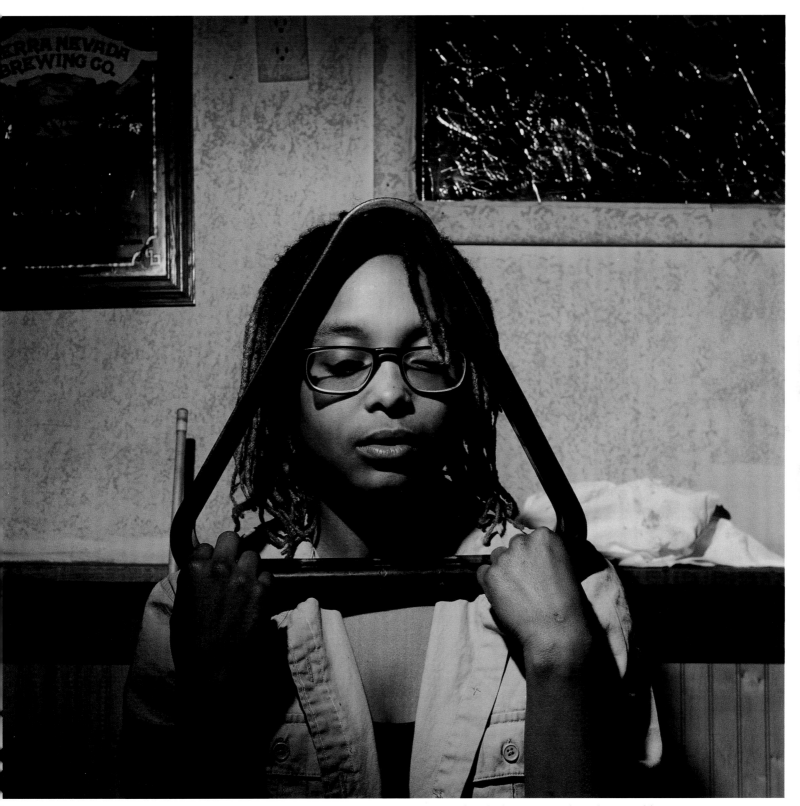

Mecca, a cousin, an artist. One of the first photographs I took when I was beginning to contemplate the limitations and peculiarities of framing.

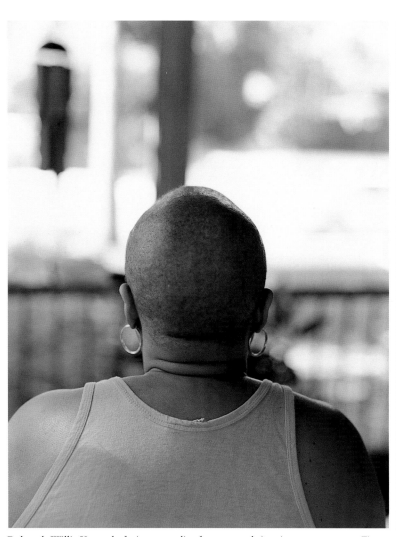 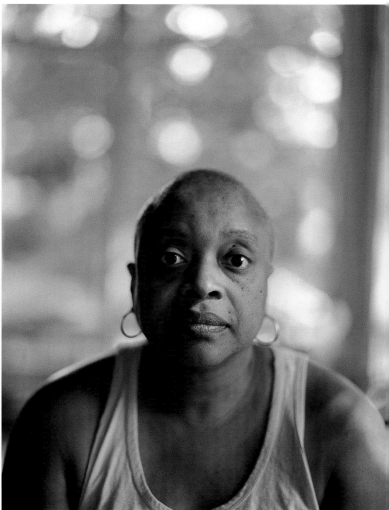

Deborah Willis Kennedy facing mortality for a second time in as many years. First, my cousin Songha was killed in Philadelphia, and then she was diagnosed with cancer.

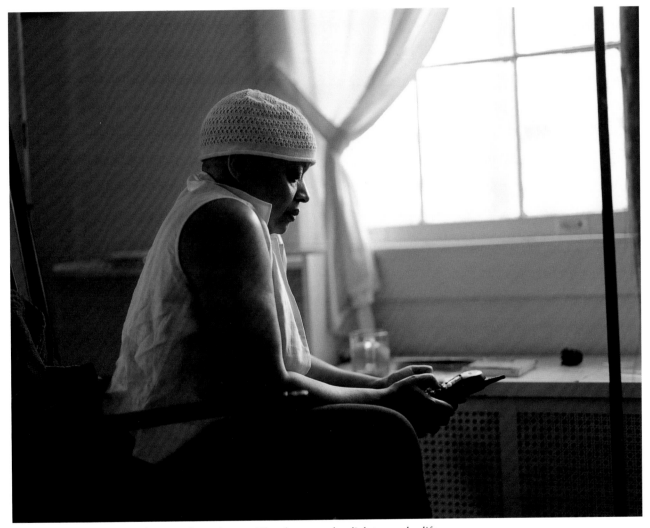

The summer my mother underwent chemotherapy. The phone was her link to regular life.

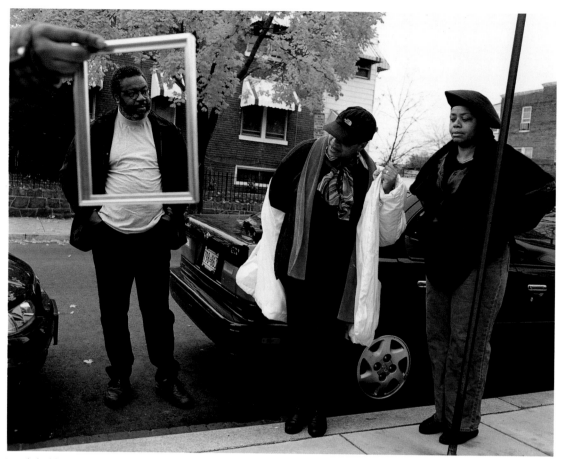

Frank holds a frame in front of Winston, who is watching my mother put on her coat. Aunt Cathy waits. When I focus my camera on something, I always have the feeling that I may be missing out on a more interesting moment happening, in that instant, not too far away.

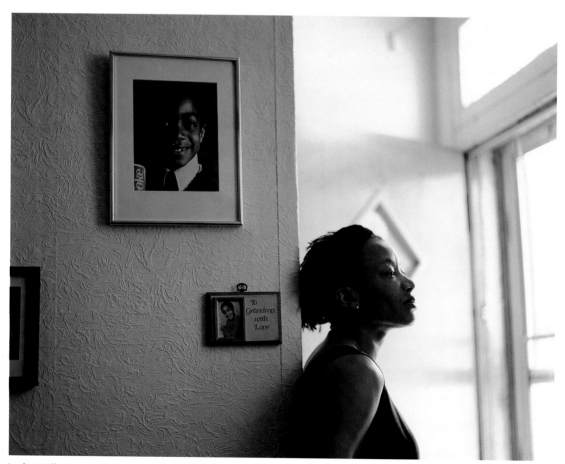

Leslie Willis-Lowry, my aunt, after Songha was robbed and murdered.

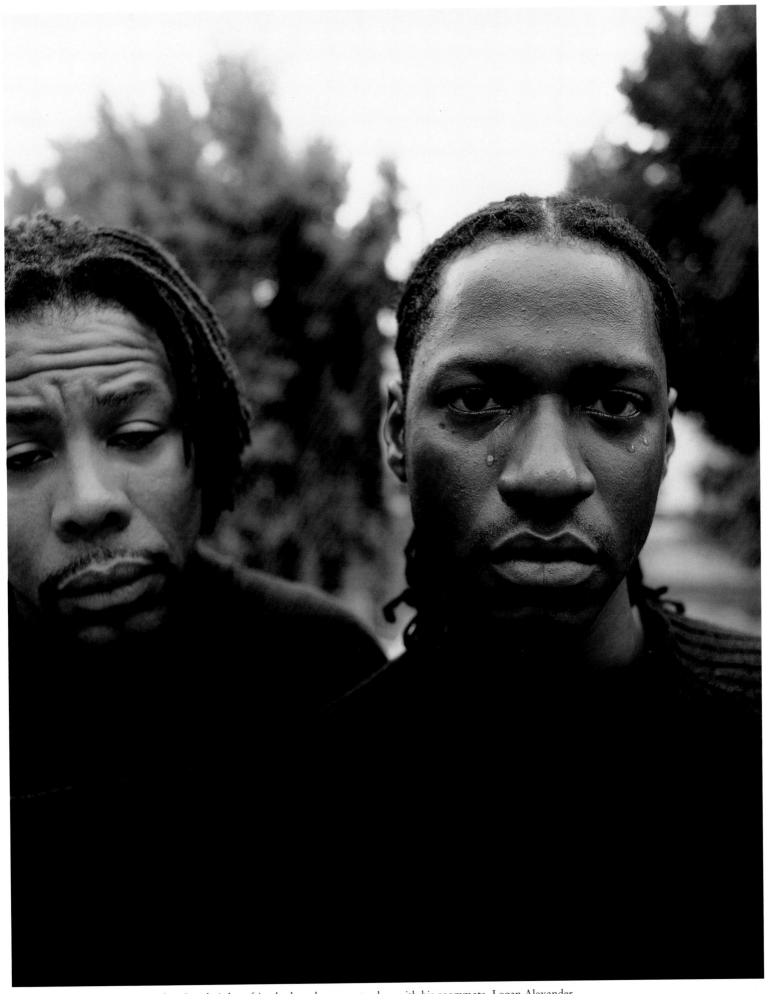

Jermaine Cheeseborough (on right), Songha's best friend when they were twelve, with his roommate, Logan Alexander.

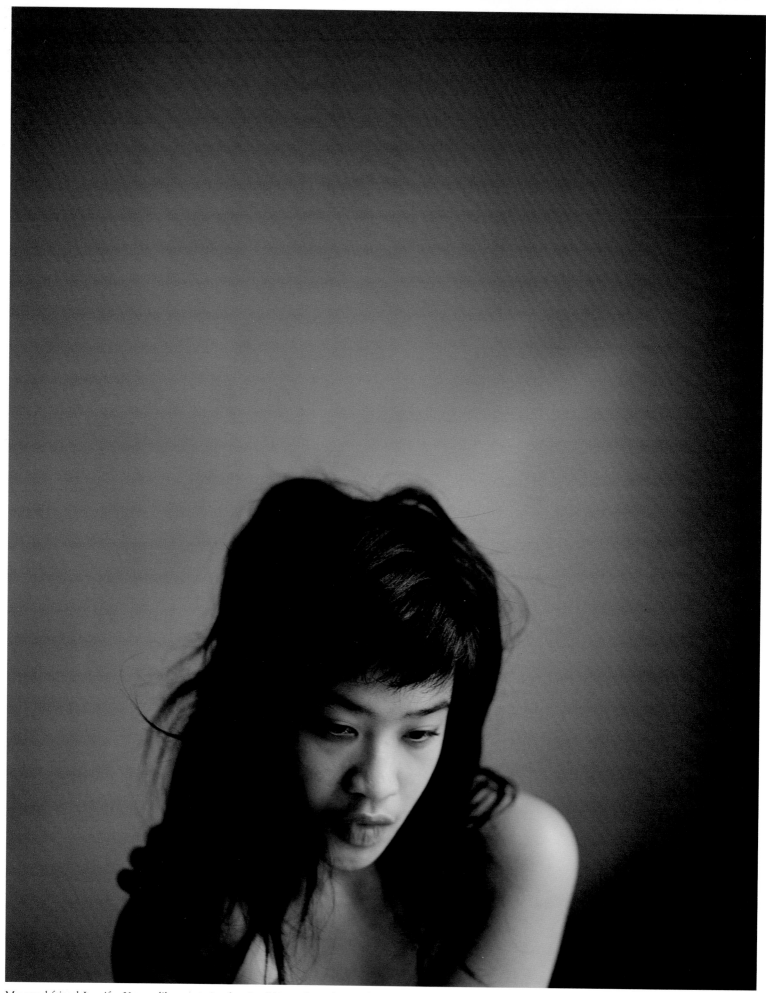

My good friend Jennifer Yazon, like most visual artists I know, hates being photographed. I don't like taking pictures of people who feel this way. So we both took a chance.

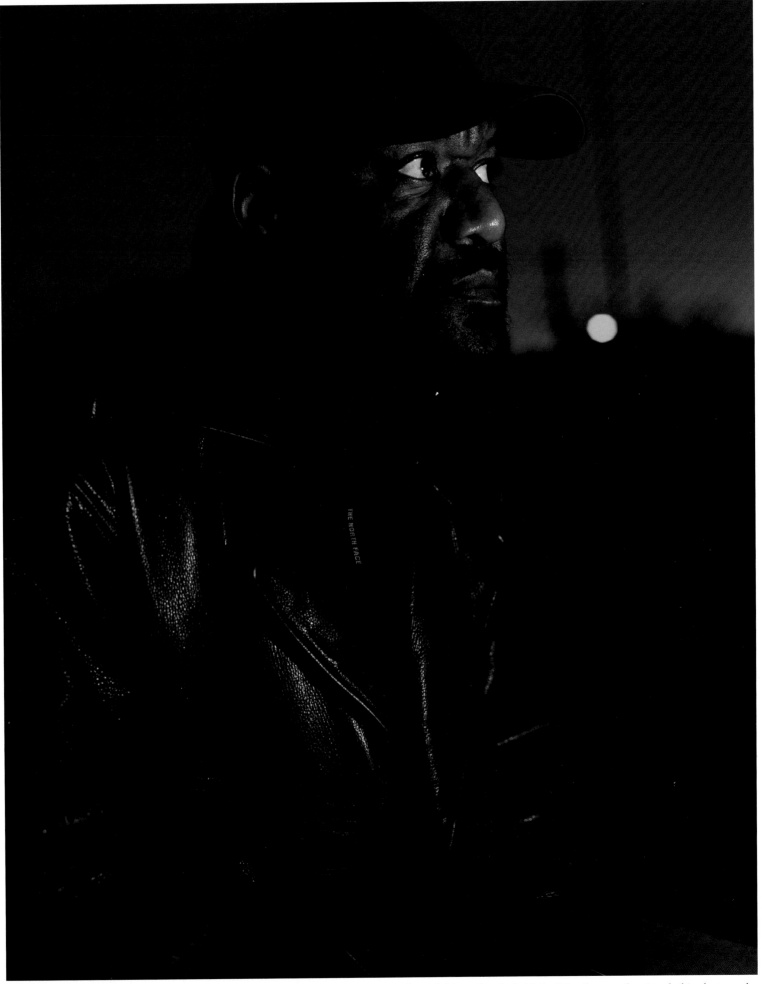

Delroy Lindo at dusk. Around this time, I decided it was necessary to take pictures of people I love. Songha held the lights for me when I took this photograph.

9/25 ɹason goodman
postcards to вangladesh

My interest in photography started in high school. Later, in college, I became interested in documentary photography. I learned that documentary photography is as much about looking at yourself as it is about looking at others. I learned too that you have to feel photography. While this approach made photography more complicated, it also made it a lot more exciting, made it a dynamic performance. I was challenged also to see the larger story at work in what I was doing.

This group of photos comes from a project about the experiences of Bangladeshi immigrants in New York City. I intended the photographs to communicate not only to a Western audience, but also to people in Bangladesh about their relatives' lives in the United States. I wanted to tell a story and explore a culture that was foreign to me, and I wanted my photos to help people understand one another better. It was a fascinating and wonderful experience. The people I was photographing were as interested in me, and where I came from, as I was in them. These photographs are really a record of our getting to know each other.

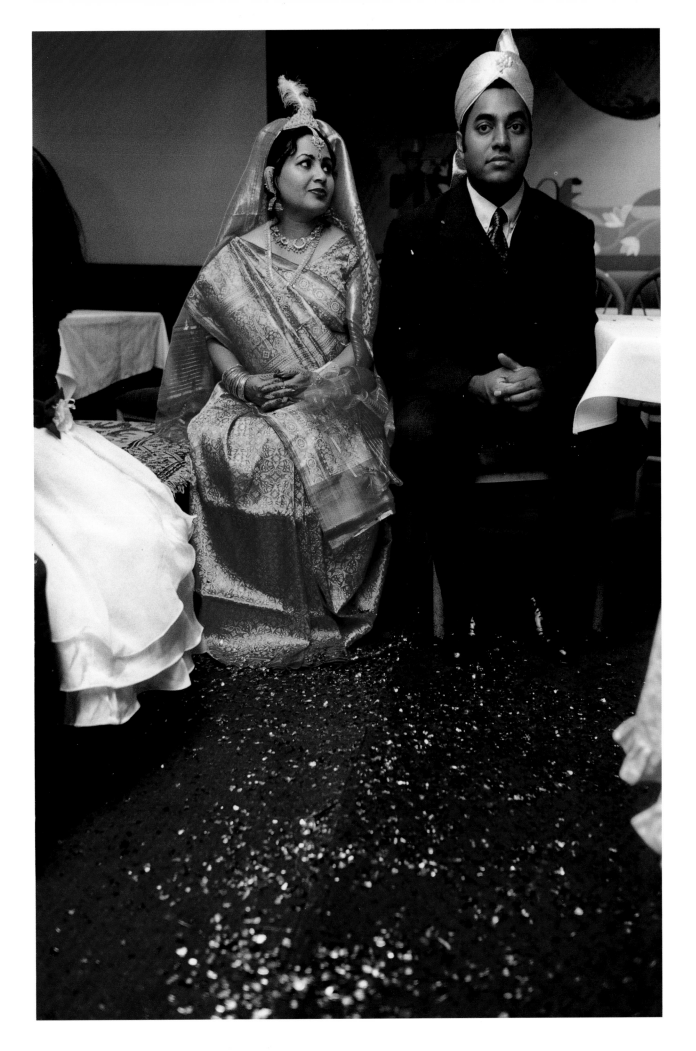

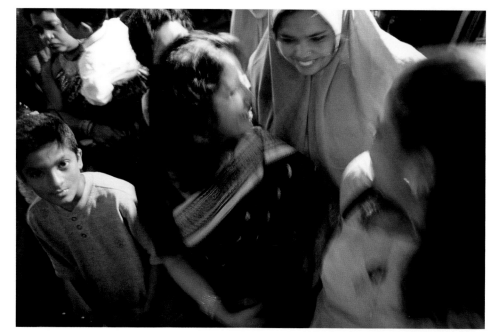

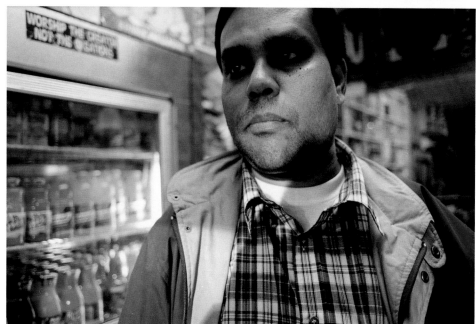

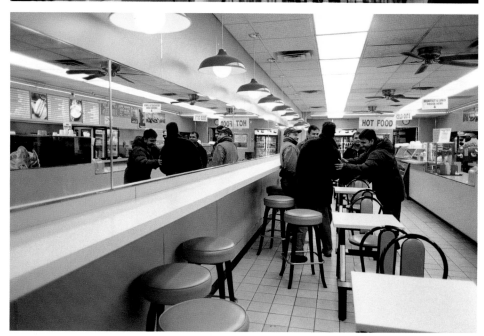

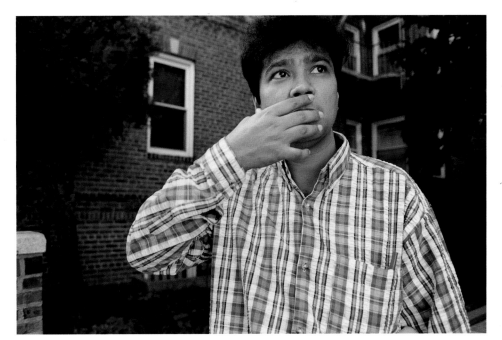

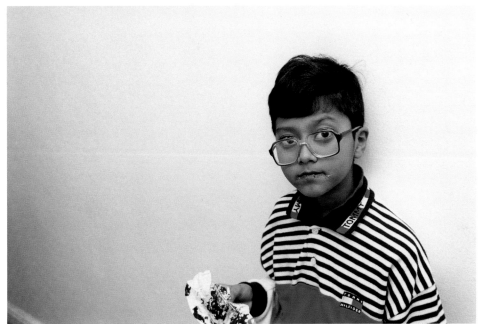

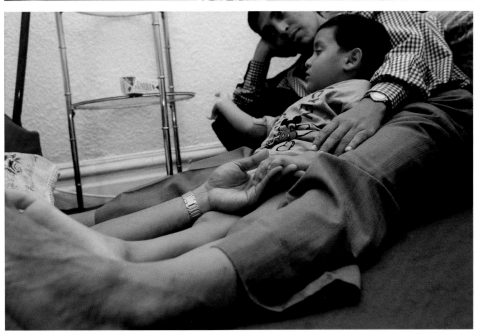

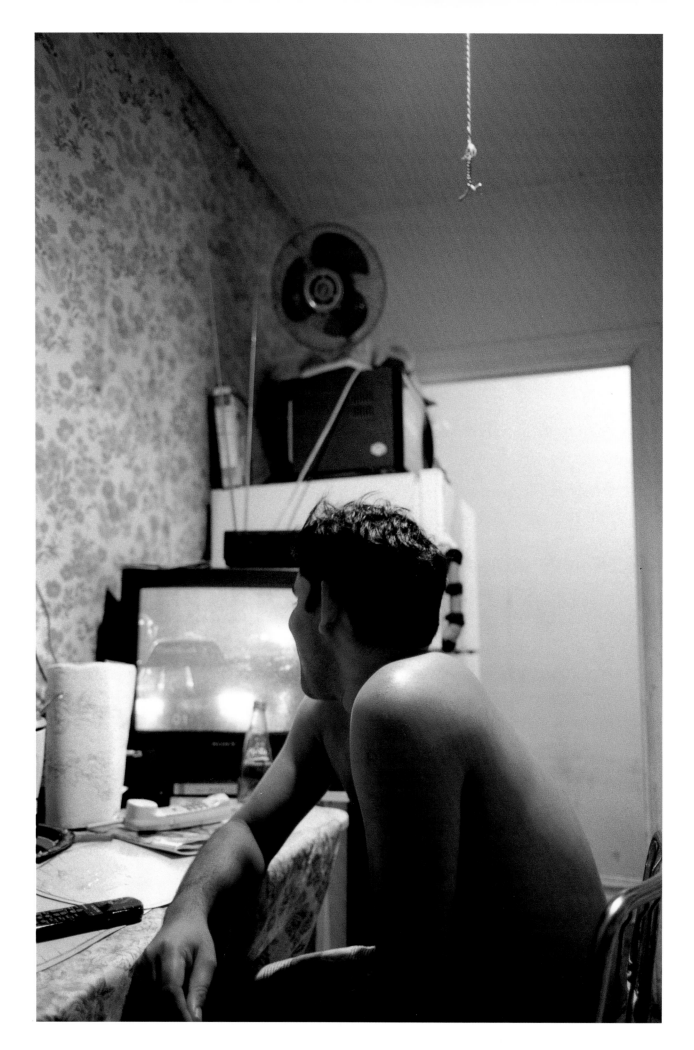

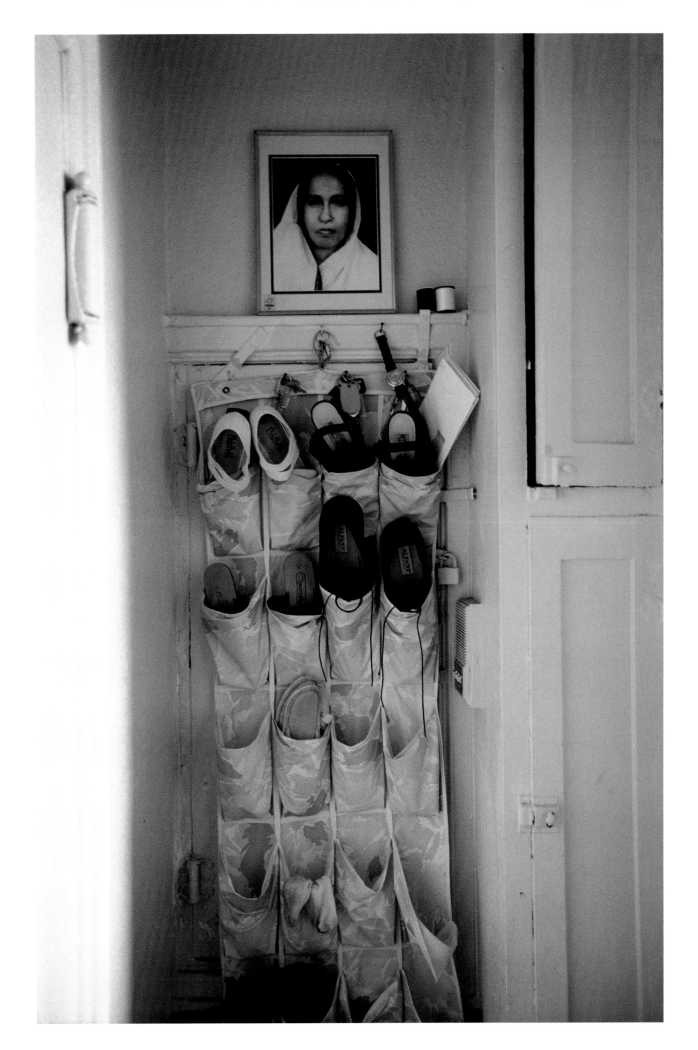

Alex Ambrose
Between Monsoons

My photographs from Southeast Asia began with a trip to Cambodia in 1998. It was my first trip to Asia, and my eyes came alive with curiosity. I have always shot with a wandering eye, focusing on timeless images of daily life. Old remnants of urban history, colorful icons, and layers of patterns and textures fascinate me. Throughout Southeast Asia I have been captivated by the beauty of the people and the interior spaces where their lives unfold. History is layered in these rooms with mundane posters, treasured knickknacks, and decades of wear. These walls and objects breathe with the lives of past generations.

Great distance has separated my life from my subjects' lives, but these photographs were made in appreciation of what we share as people, looking to grow and survive in this world. Everyday I found myself compelled to shoot what was familiar to me: flipping TV channels to ease the boredom of an afternoon, sitting in thoughtful loneliness, day-dreaming on a crowded city street, or getting a much-needed haircut. I was drawn to make these images because they were the closest, most sincere, connection I could make. Our lives mingled together in a common moment through the lens and our differences faded away.

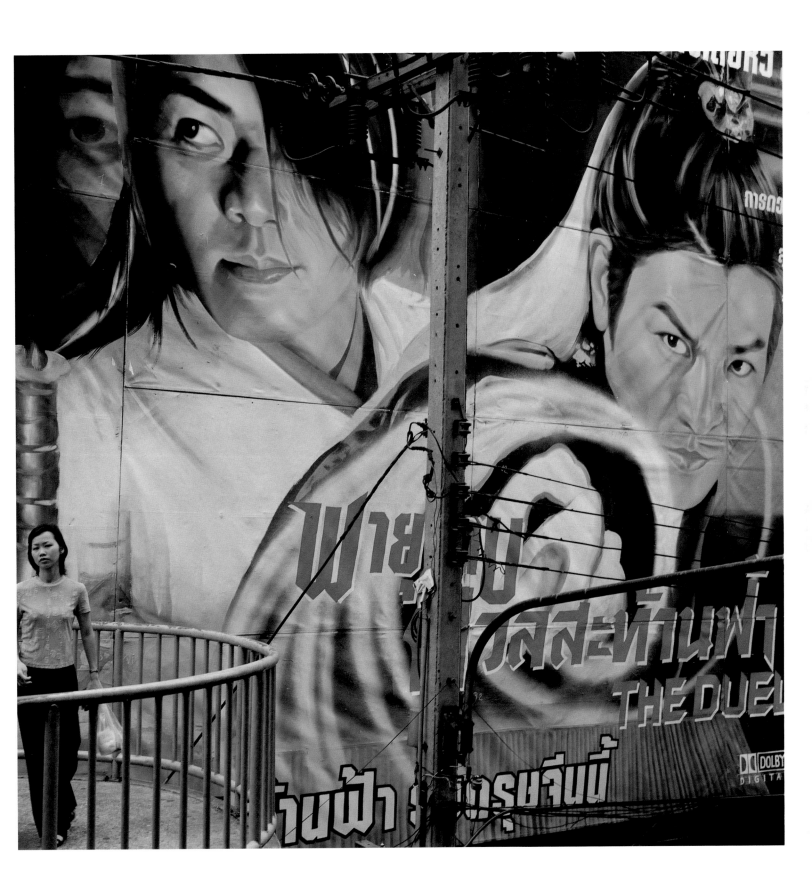

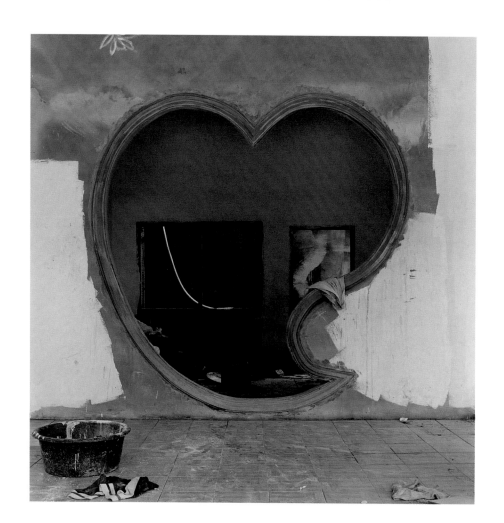

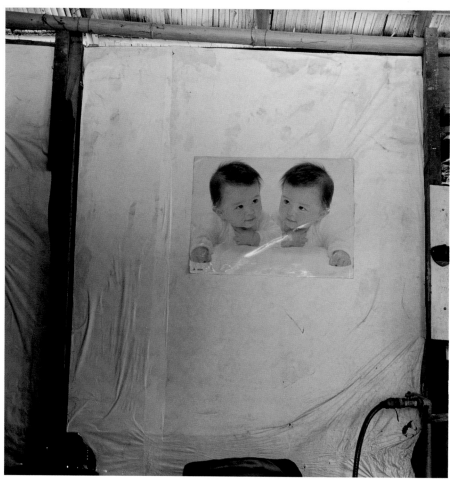

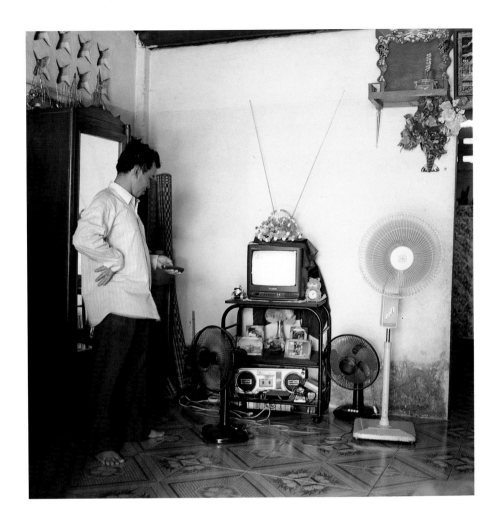

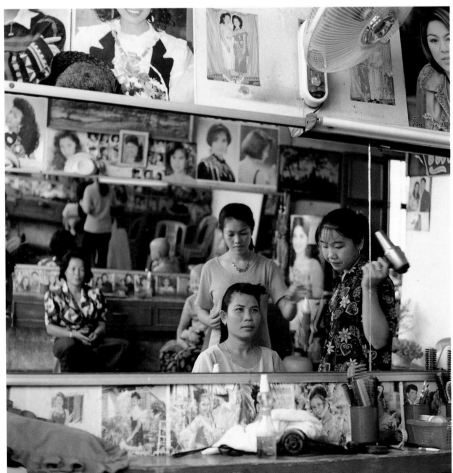

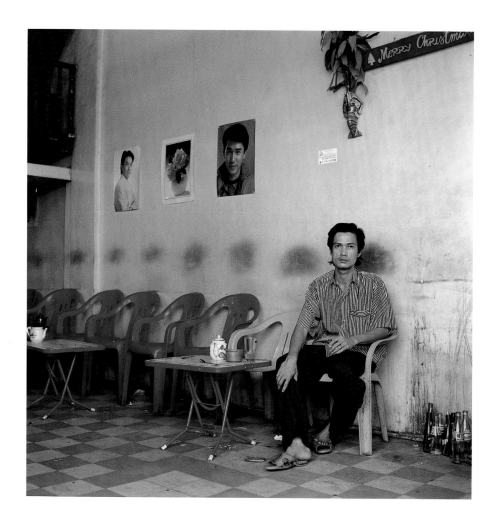

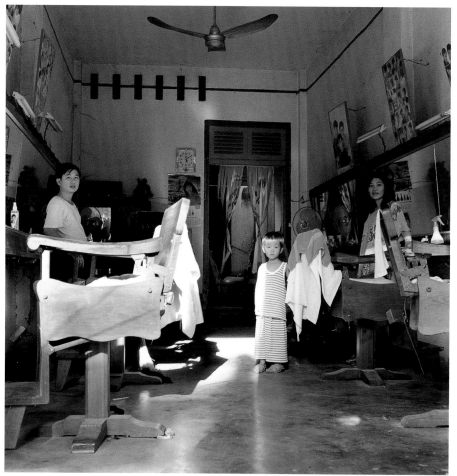

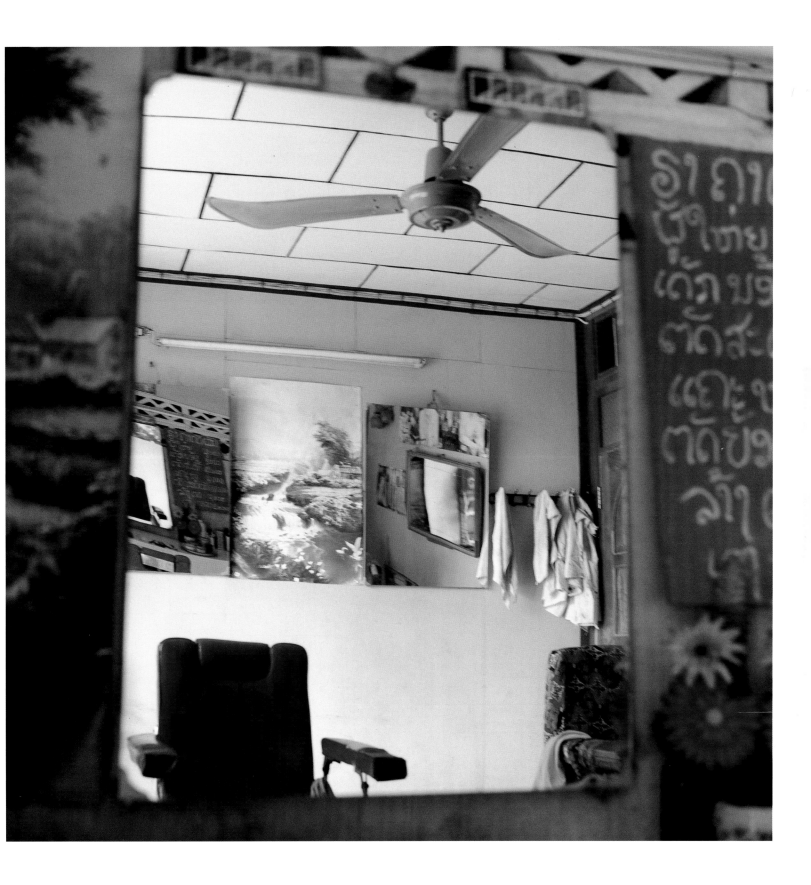

Jen Moon
After Midnight, Before Six A.M.

I've composed pictures in my mind for as long as I can remember. At eighteen I got my first camera, and in my first semester in college I started studying photography. I have a one-track mind, and I fell in love with the process—the conception, execution, and printing of a photo. Still, there was something missing. One night I turned down a road I thought led to nowhere, but it started me on a new path. On that road, in the darkness, a factory became a glowing tower, and it changed everything for me. I drive around at night and watch. I find my own empty sets to tell stories.

Iowa City looks like every other small town in Iowa. At night, in the dark, through my camera lens, I fell in love with the place. Silos are beautiful cylinders. The tiny town's lights are starbursts, and the skyline is defined, as it never could be during the day. There's no dust, no commotion, no noise. There are no people in these images. At night the rules change; anything can and does happen. I try to remain open to the transformation the world undergoes when most people are asleep. Through the filter of darkness, under the streetlights, a society's ills and outcasts redefine themselves. So I look for the real and the magical and am constantly surprised.

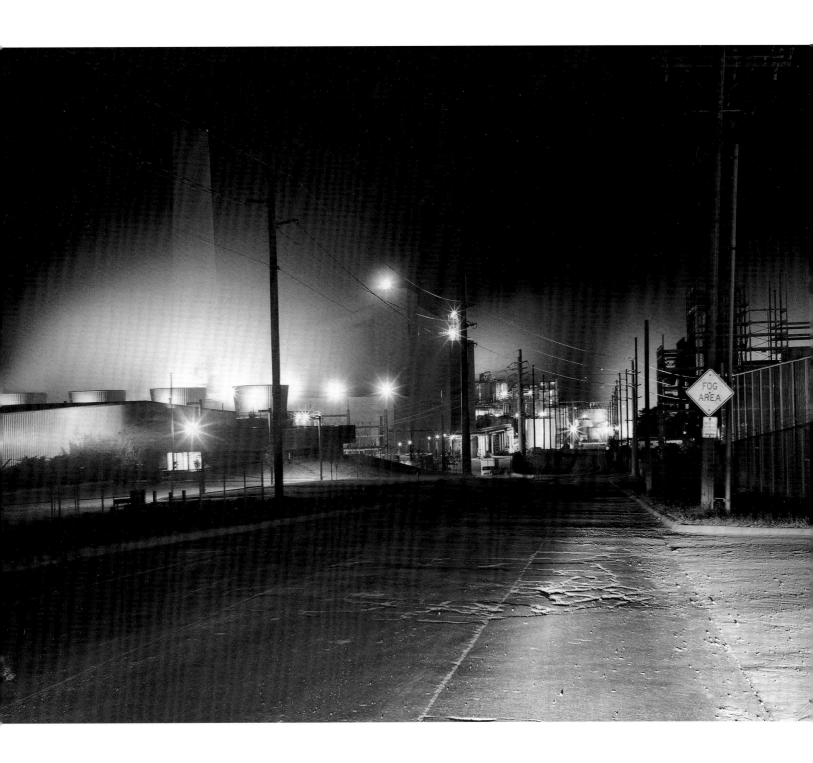

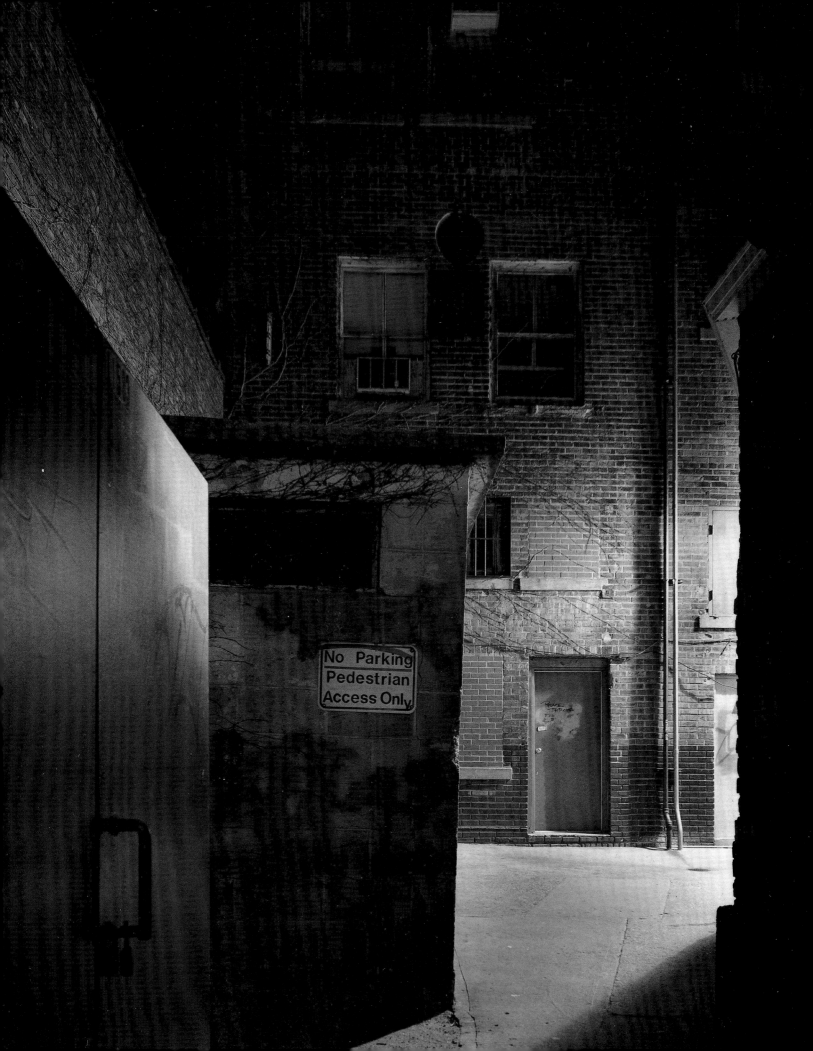

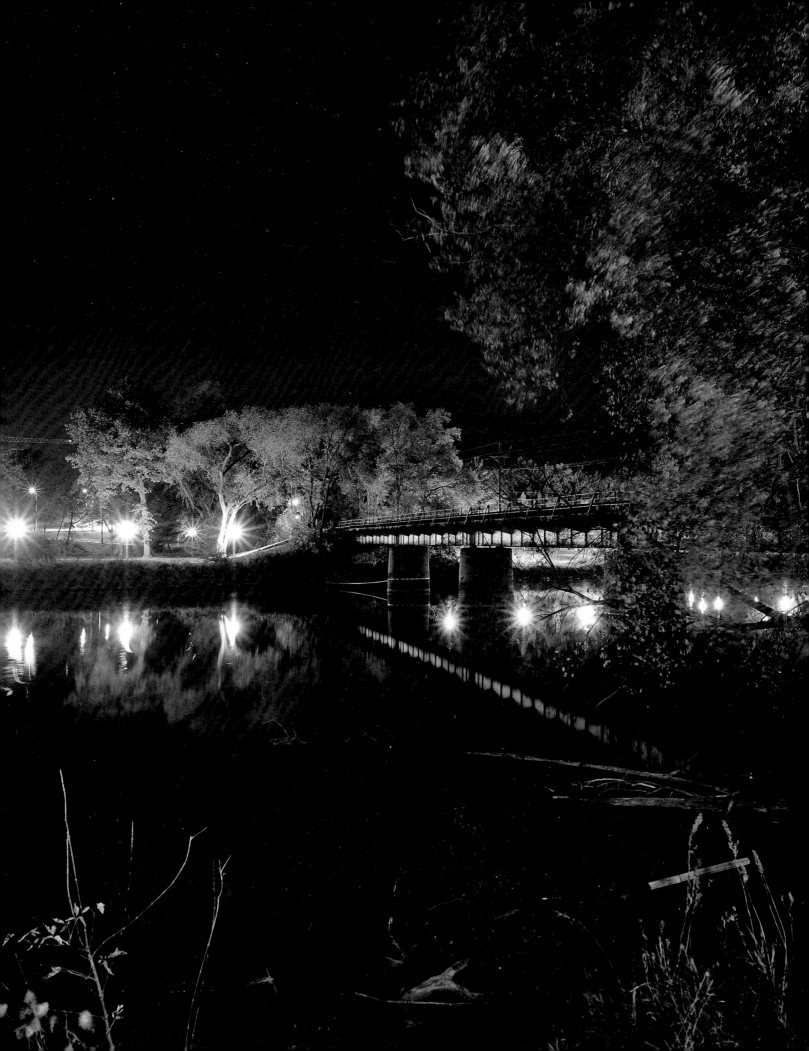

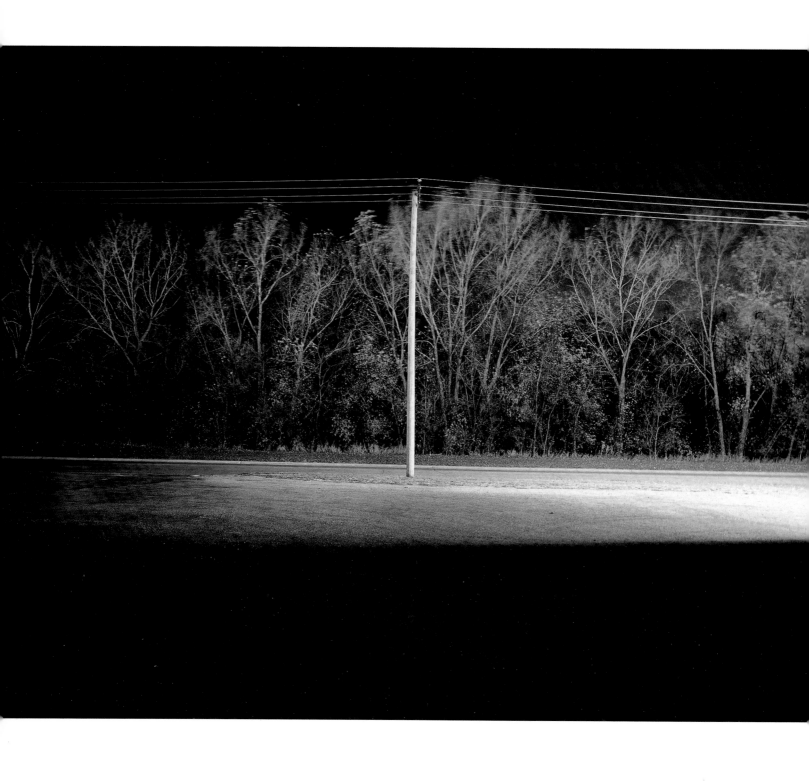

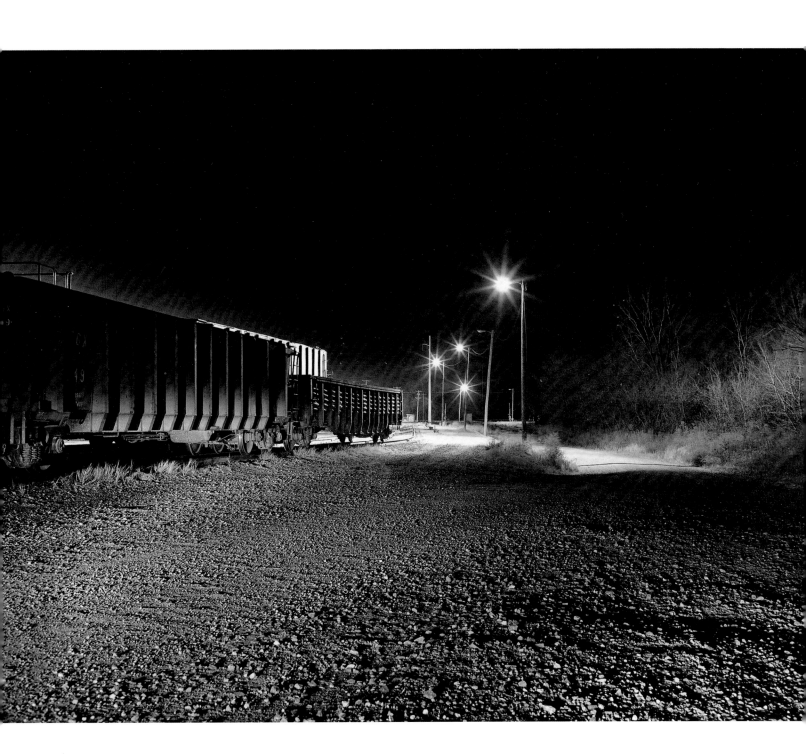

12
25 **Isabelle Lutterodt**
Residue

At the age of twelve I took my first picture using my father's camera. While this piqued my curiosity enough to enroll in photo classes, my deeper interest in photography was fueled by an exhibition of Robert Frank's *Moving Out*.

This project is a response to what I see as the interweaving of fact and mythology in the telling of America's history. I began by examining romantic stories of the antebellum Mammy and how this figure, during Reconstruction and beyond, was remade as the domestic worker. As this series of photographs unfolds, the viewer sees dark hands mixing white dough, and the hands gradually get blacker. The text begins with the definitions of two words (sentimental and memories), and chronicles women talking about their experiences as domestic workers. The work selected for inclusion here is part of a longer piece about the history of soul food in the black community.

My purpose as an artist is to question, reassemble, and reassess the answers we have traditionally been given about ourselves. I hope that my work will never stop getting people to ask questions.

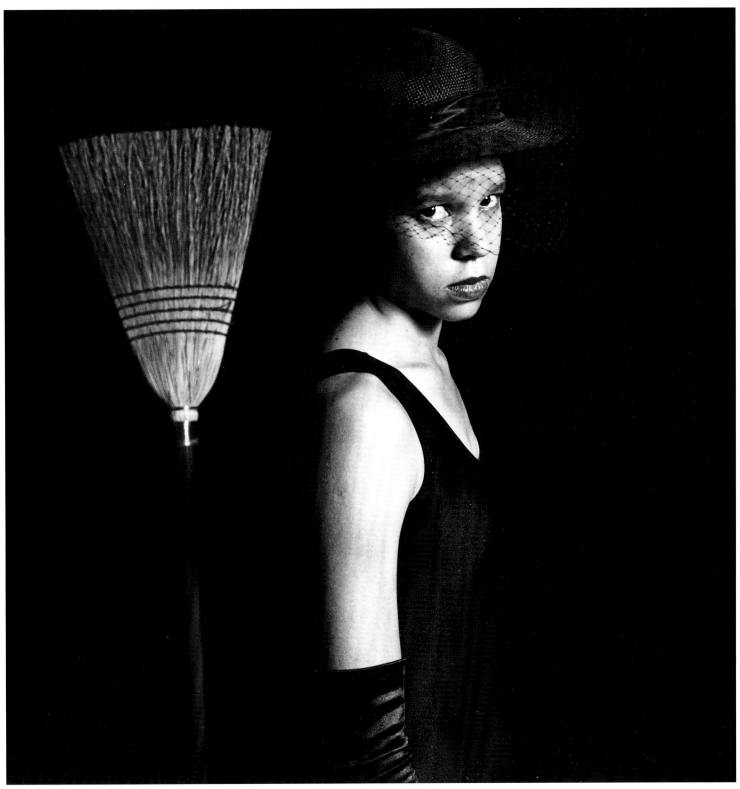

Sentimental: *adj.* **1.** expressive, of or appealing to sentiment, esp. the tender emotions.
Memories: **1.** the facility or process of retaining or recalling past experiences.

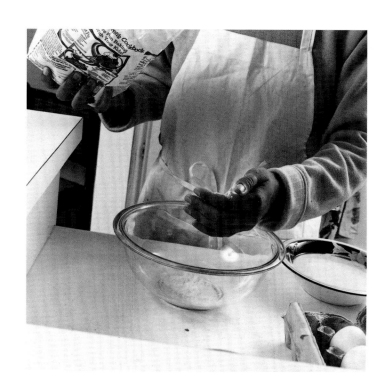

How come everybody run off from Sweet Home can't stop talking about it? Look like if it were so sweet you would have stayed…. It wasn't sweet and it sure wasn't home.

—Toni Morrison, from *Beloved* (1991)

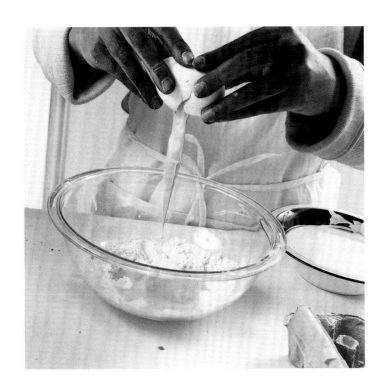 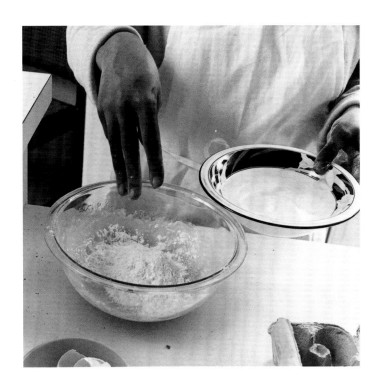

The recipe calls for flour, eggs, sugar,
and a sprinkle of water.
Combine all ingredients in a large bowl.
Mix well.
Bake.

 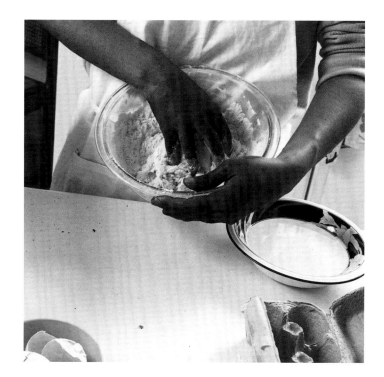

You ever thought of that—
why Aunt Jemima ain't on the grits box?
That apron was not for me,
and right now that apron is right there now.

—Susan Tucker, from *Telling Memories Among Southern Women:
Domestic Workers and Their Employees in the Segregated South* (1988)

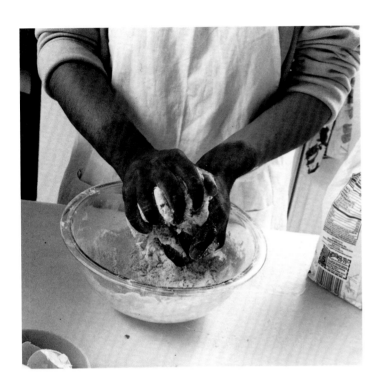 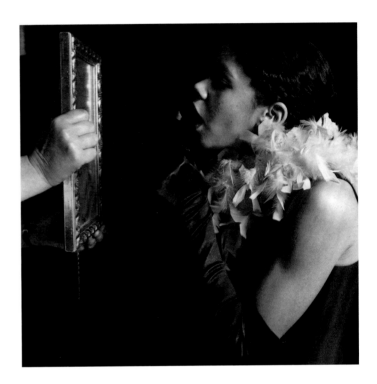

If there is any word that arouses emotion in the heart
of a true southerner, it is the word "mammy."
His mind goes back to the tender embraces,
the watchful eyes, the cooning melodies,
which lulled him to rest, the sweet black face.
"What a memory," he exclaims.

—Charlotte Hawkins Brown, from *"Mammy": An Appeal to the Heart of the South* (1919)

13/25 Brian McKee
Soviet Military Base, Former East Germany

When I was fifteen my best friend and I took a road trip to the Dakotas, and along the way I began taking photos: a truck stop, a herd of cattle, old barns. At college my thesis was a sequence of thirty "Dark and Marginal" images of historic sites across the United States. After college, I wanted to do something similar in Europe and decided to photograph the remains of East Germany: the empty factories, military camps, and apartment buildings. A huge range of emotions and ideas began to form as I made these photos. Many of the rooms appeared to have been untouched since they were abandoned, and I felt as if I were trespassing on the past.

I work with an 8x10 camera, so I move slowly and get to know the spaces well. My work is primarily concerned with specific historical events and our relationship to those events. I am fascinated by how we define history, how we use events and objects to create a historical record. For this project I chose the Communist occupation of the former East Germany as my subject matter. If you look at these images as a group, a mysterious and unnerving story from the not-so-distant past begins to emerge, a story of now-empty rooms, abandoned possessions, peeling wallpaper, and the collapse of Communist control over Eastern Europe. It is their context that gives these ruined places such rich meaning, calling up European history—memories of past wars, of the Cold War, of human lives.

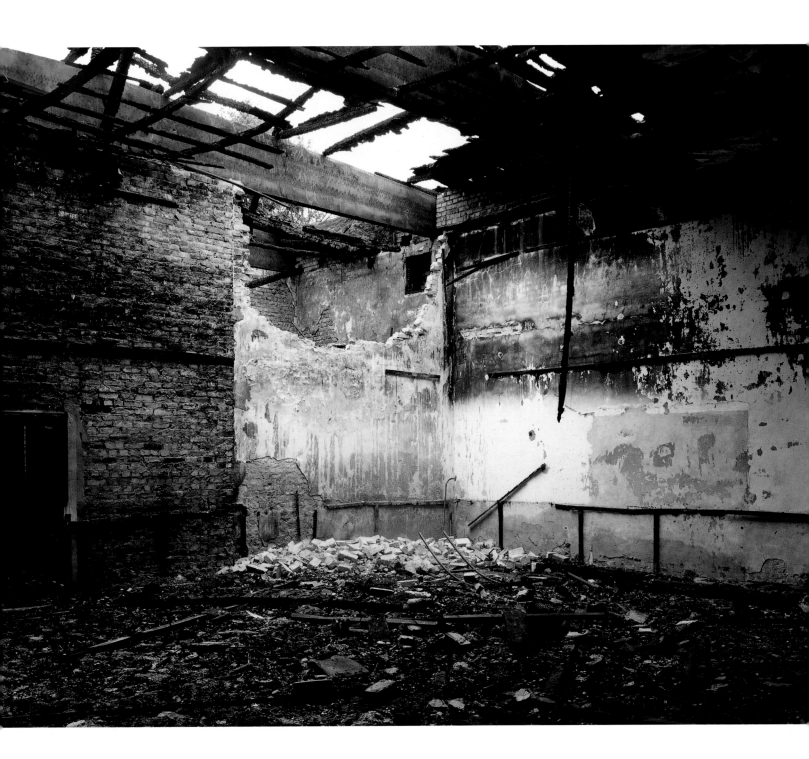

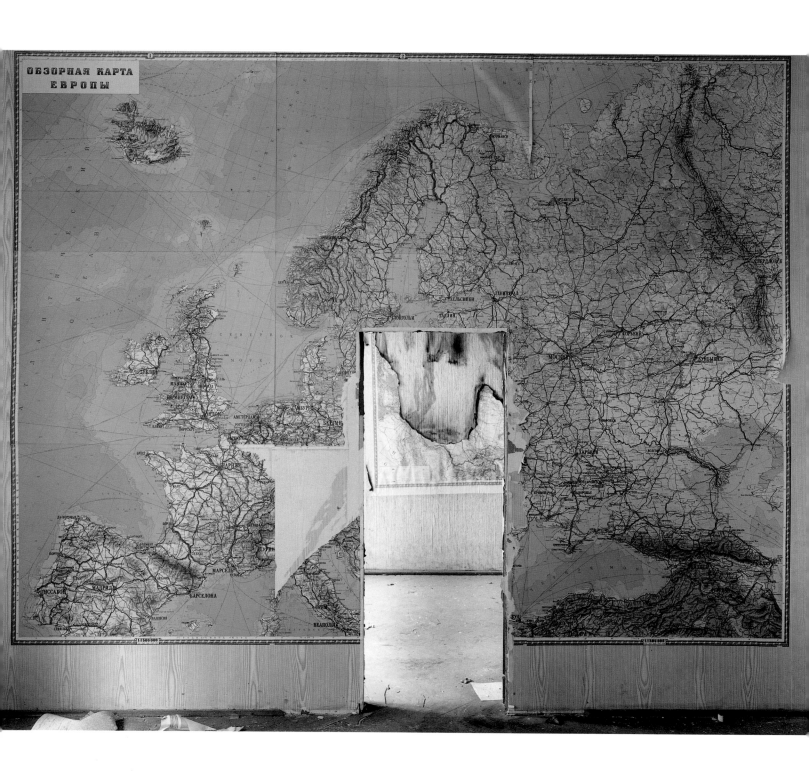

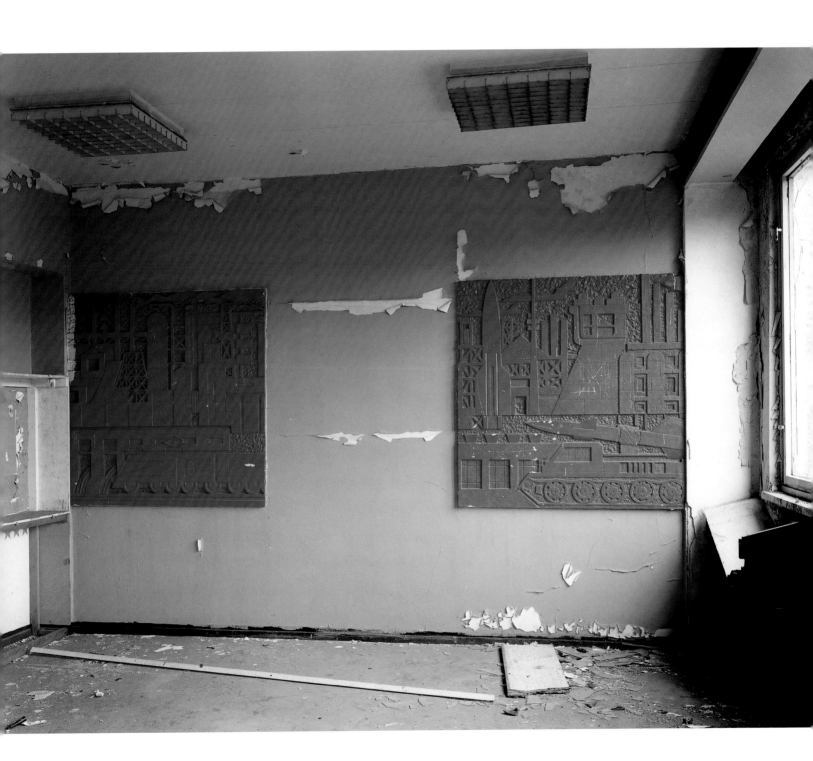

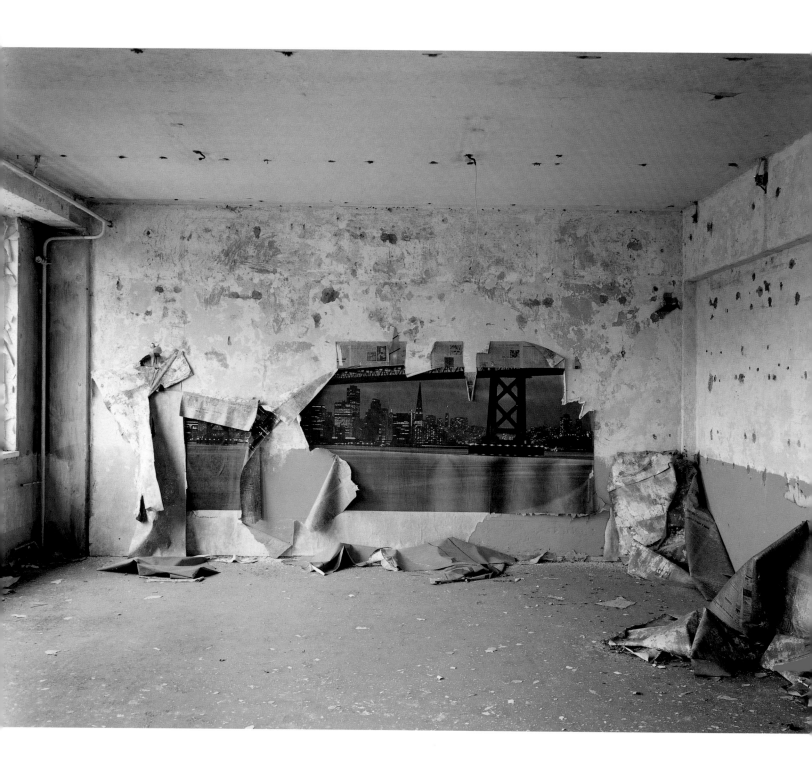

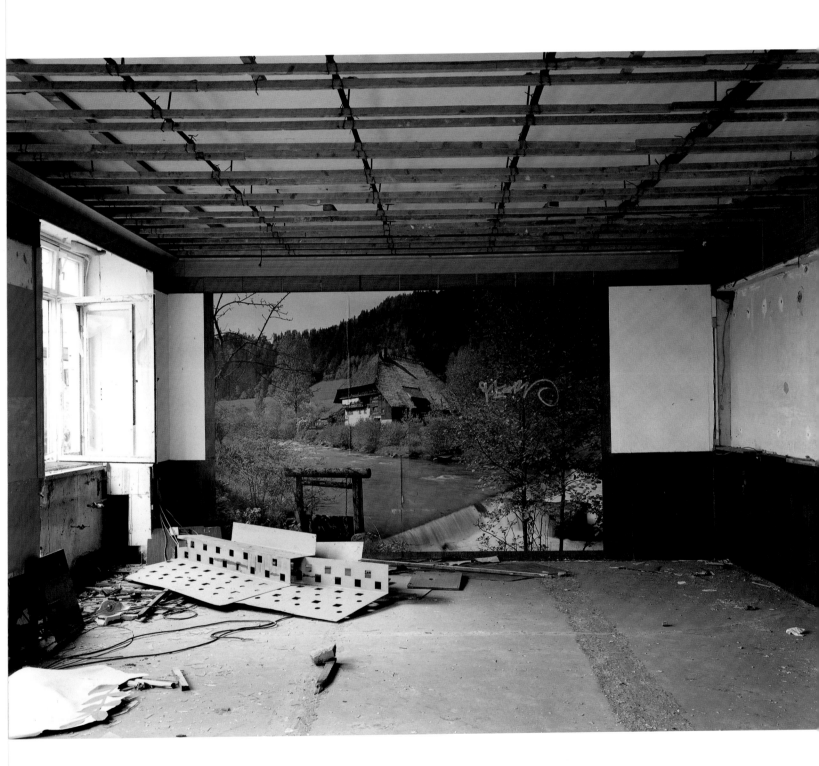

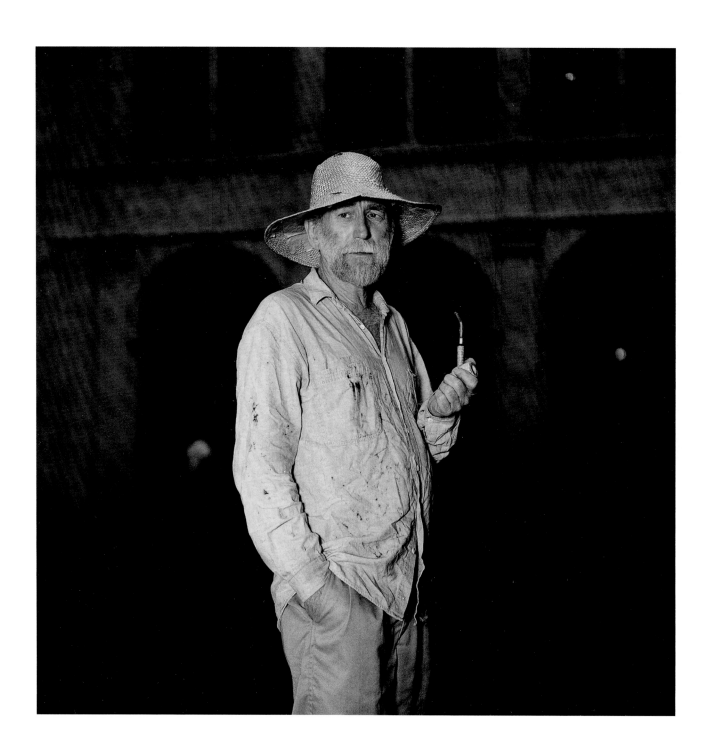

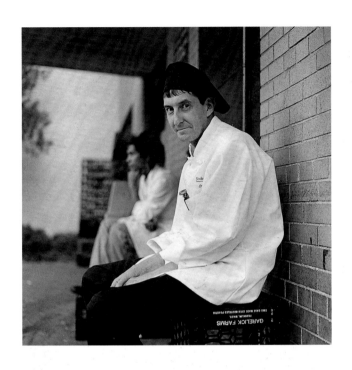
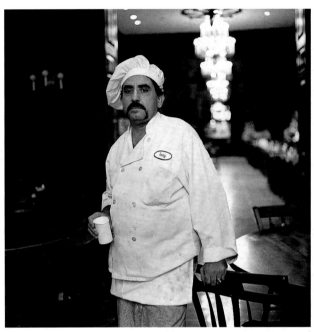
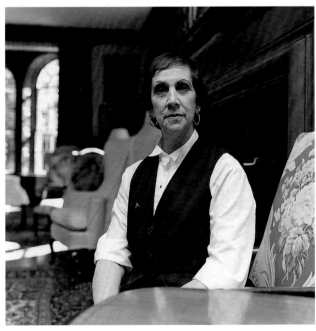
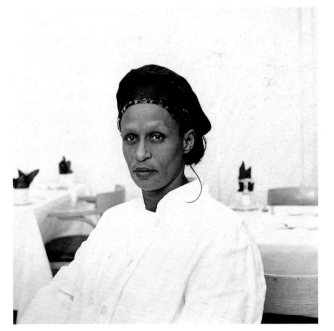

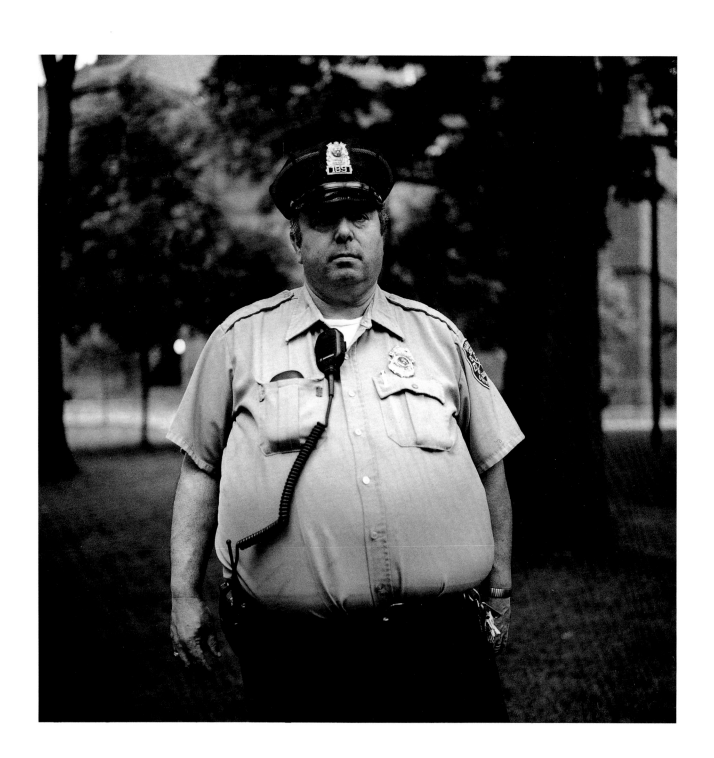

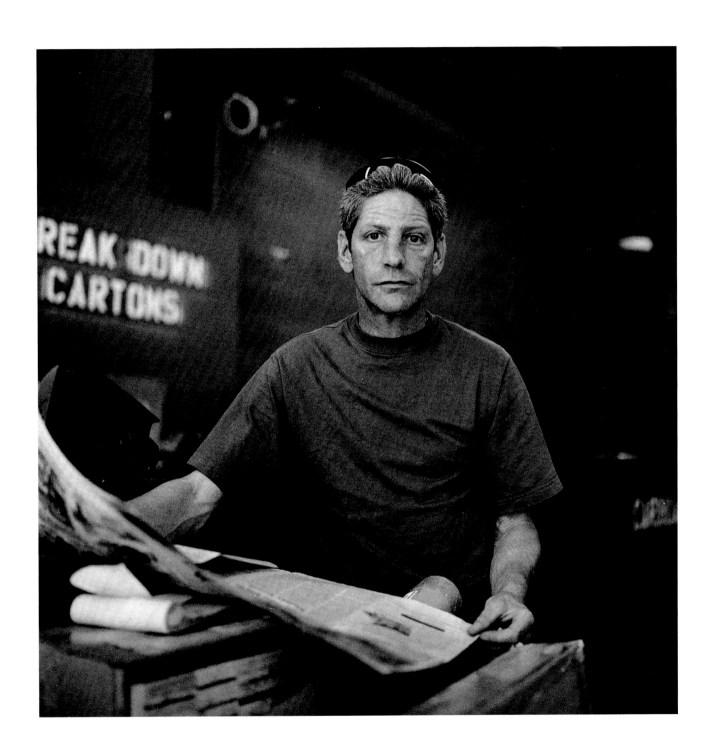

kristin posehn
broad stripes, bright stars

What at the time seemed chance, in retrospect was providence—halfway through college I took a documentary photography class that opened me up to a whole new way of seeing. We photographed a community over the course of a semester, mine was a local Wal-Mart. Suddenly pictures were an evolving experiment. By looking deeper into my surroundings, into myself, my perception could change and grow.

This particular work is from a body of photographs made at carnivals, fairs, and festivals. It happened naturally and without my planning. These places resonate with me for their intensity of color, their sense of play, abandon, and freedom. They are a space for entertainment outside the everyday, a dynamic and colorful microcosm. But there is always a sense of gravity there too. When you let your hair down you show you're ready for change. We reveal ourselves in play.

Photography has been an exciting journey for me thus far. I can't imagine not photographing—it just keeps happening all the time. I divide my time evenly between photography and sculpture, and I find the two intertwine in fascinating ways. Both are central to my practice as an artist.

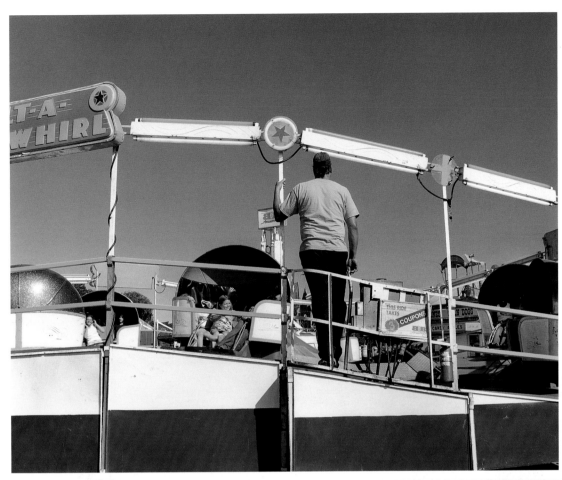

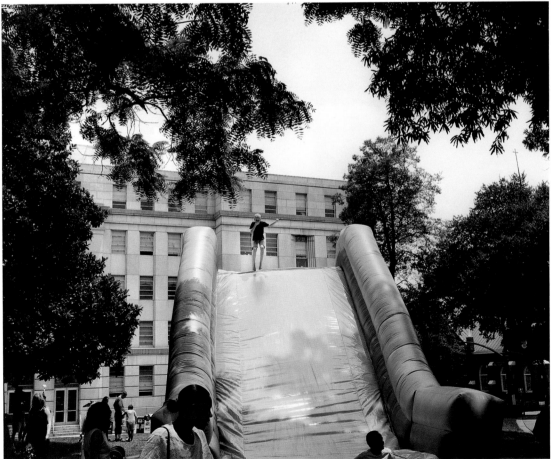

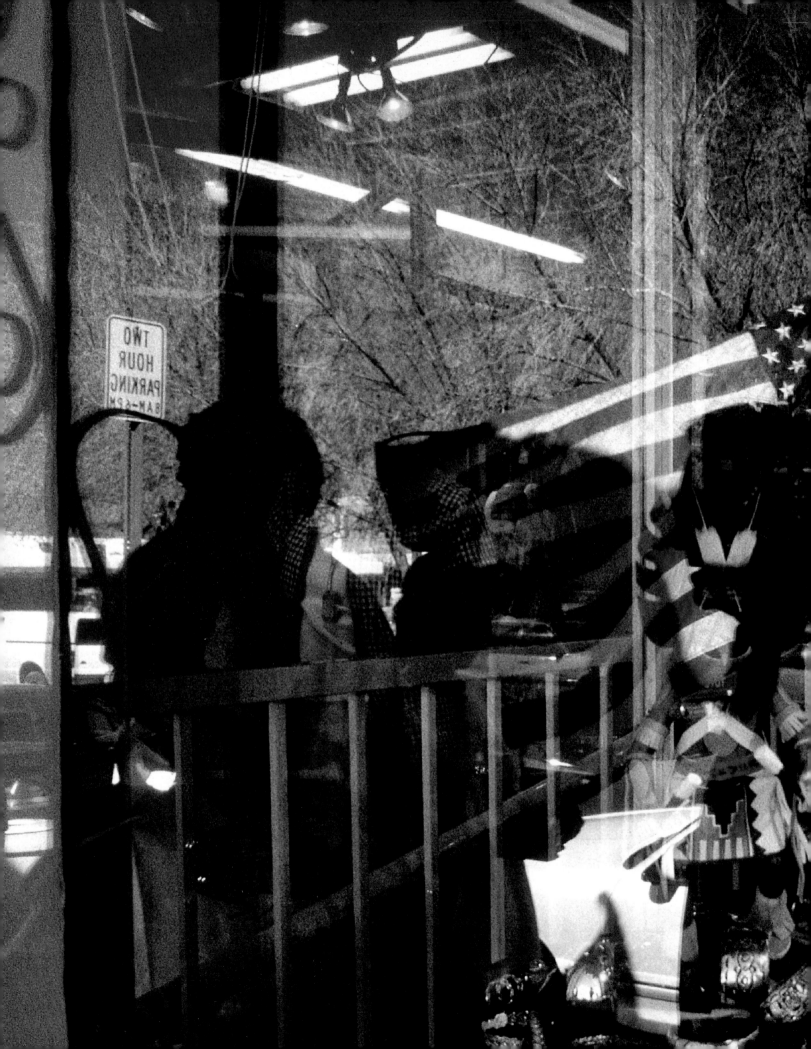

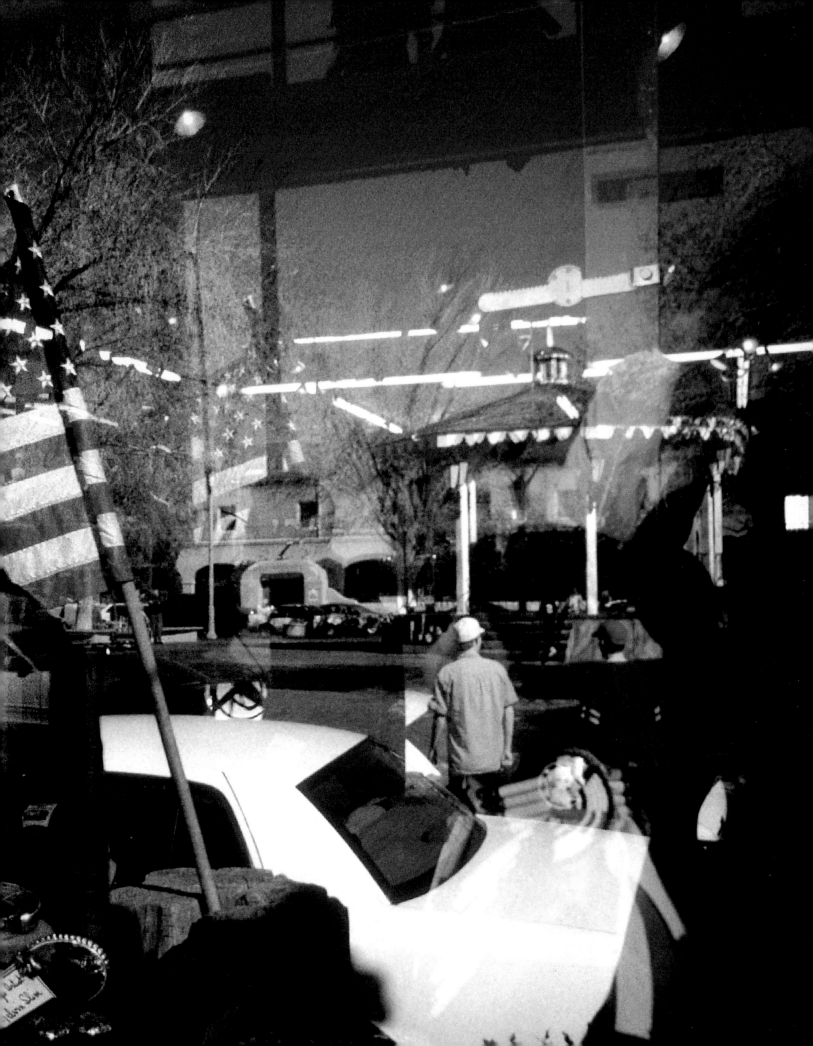

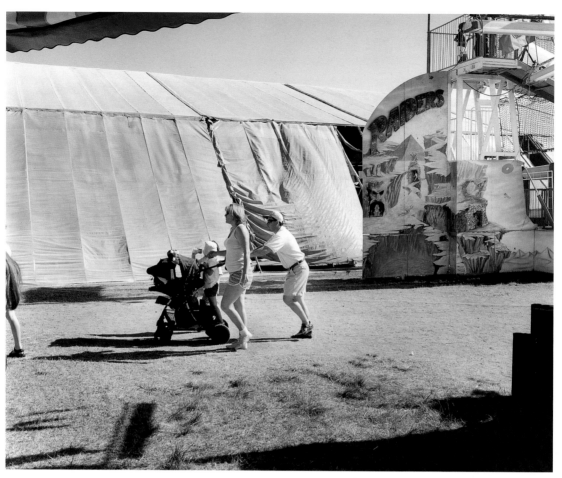

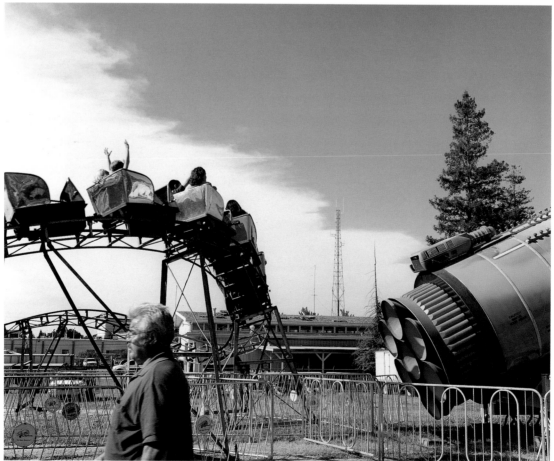

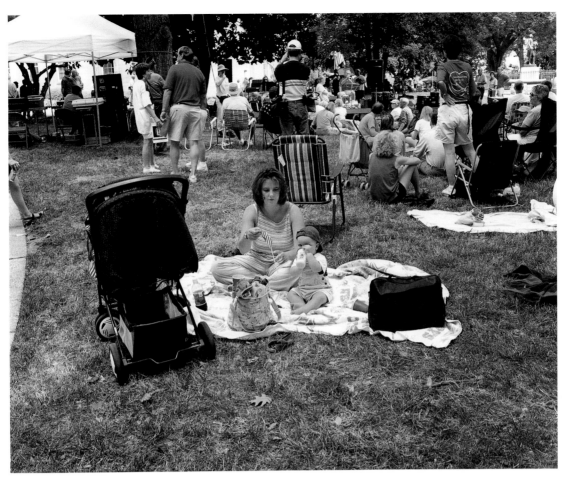

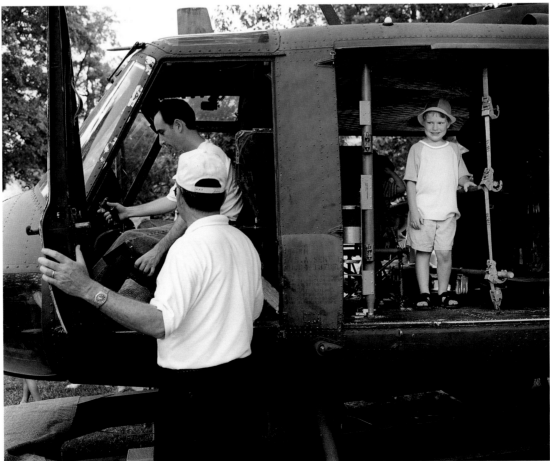

Jessica Ingram
under one roof

When I was a child, my mom gave me a 110 camera, and I took pictures of everything. The summer before I photographed this body of work, I made pictures of my own family. I was interested in the connections between family members, and my relationship to my family. When I returned to New York in the fall of 1998, I asked my friend Kareem if I could photograph his family.

I met Kareem in 1995 at Washington Houses Community Center in East Harlem. He and his brothers worked there. I taught photography, and Enola, Kareem's little sister, was in my group. Their family allowed me into their home and to have access to their private moments. They let me in as a member of the family, and we are still close. The process of developing this project was, and remains, so important to me.

Several generations lived in this house, and each person played many roles: Denise, as mother and grandmother; Melissa, mother, daughter, and sister; Kareem, Tarik, and Joe, sons and brothers and uncles. I like the play of the pictures together, how they interact and reveal the family's dynamics. Many of the family members have moved out, so I am glad I captured them at this time when they were together.

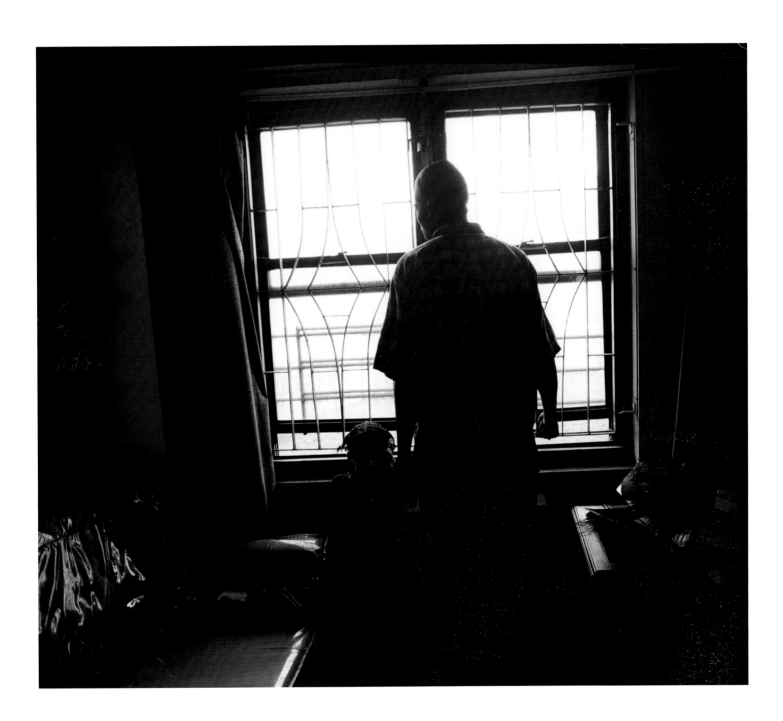

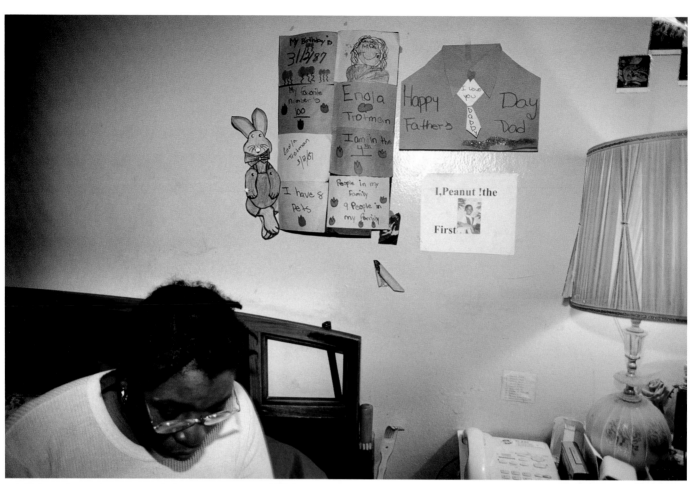

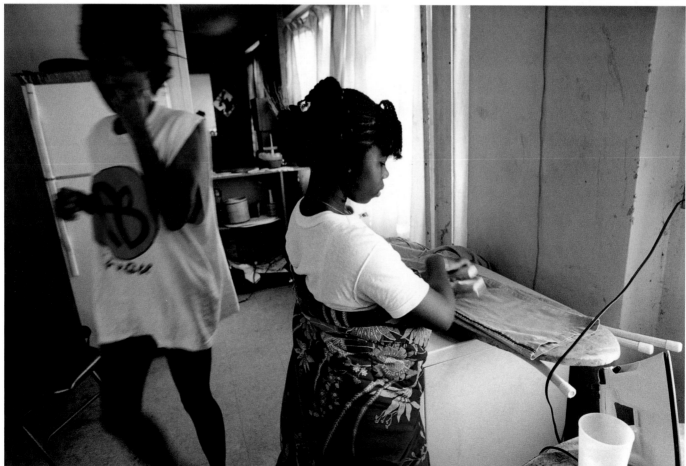

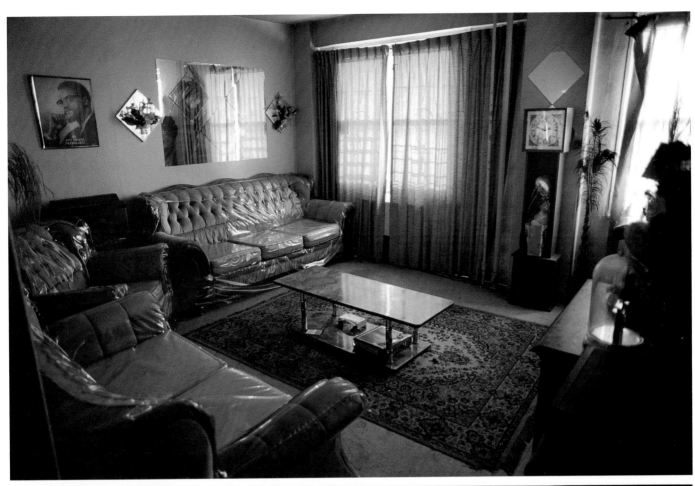

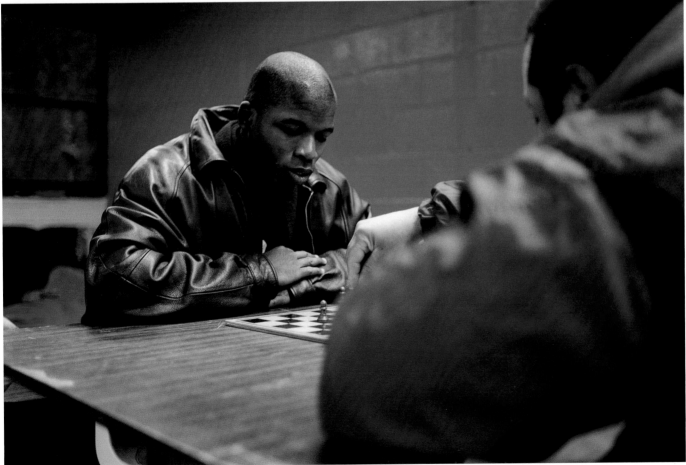

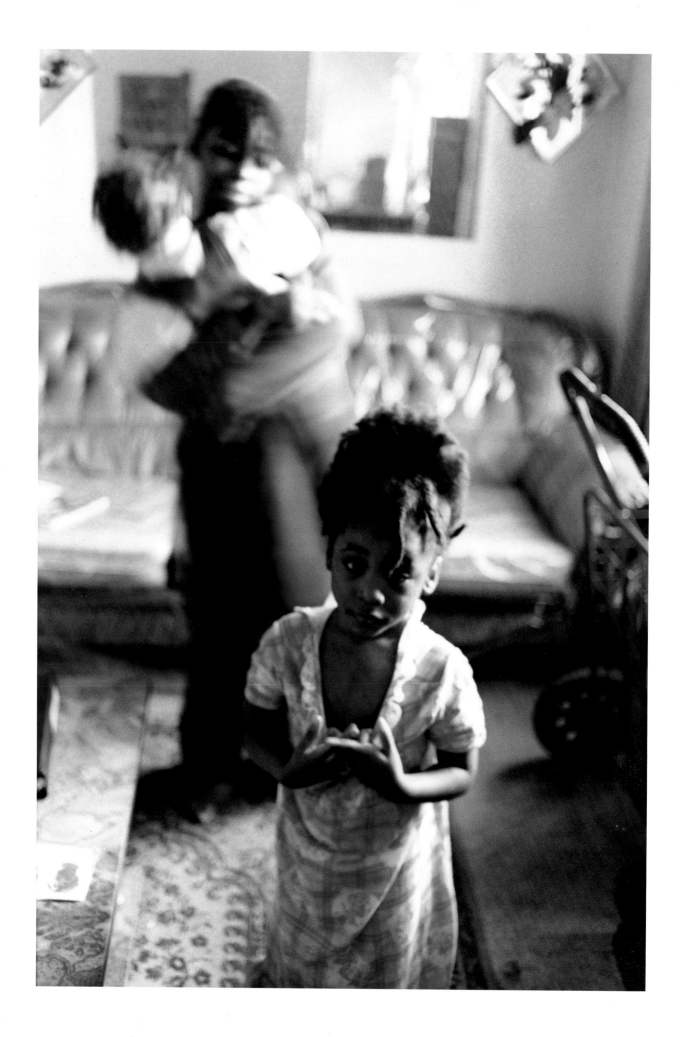

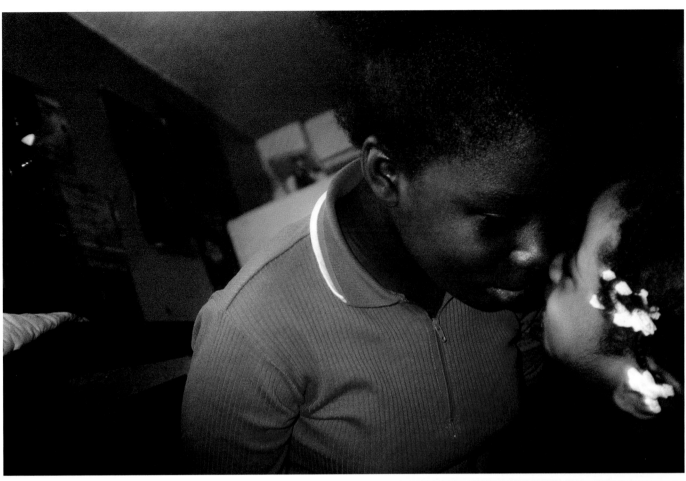
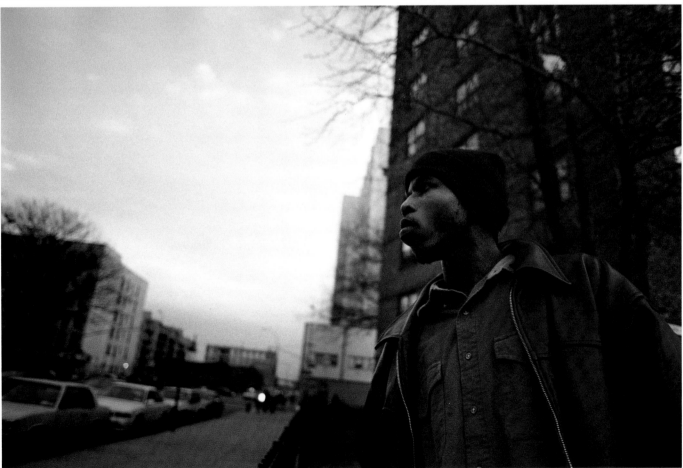

I am the first born of modest parentage from a modest town in one of this country's most modest states. Nearly everybody in my family lives within one half hour of each other, except me. I've strayed away for now (and miss them). I left for college absolutely committed to becoming a photographer. I also wanted to live in a place offering more diversity in thought, religion, employment, race, and ethnicity. New York City is magical that way, and it was a playground for me.

This work was part of my senior thesis project focusing on the dreams of senior citizens. A friend whose grandmother lives on the same Brooklyn street introduced me to Abe. Abe is a widowed and retired dentist who wants the U.S. government to develop a Universal Health Care Program providing adequate health coverage for each of its citizens. His passion for social policy served as a focus for many of our conversations. At first, I had great difficulty marrying the photographs to words and ideas about Abe's dreams. With time I came to realize that the photographs had taken on a meaning of their own. They are in part a sedimentary layer of curiosities, the objects and memories that for whatever reason stay with a person and sometimes gather beneath him.

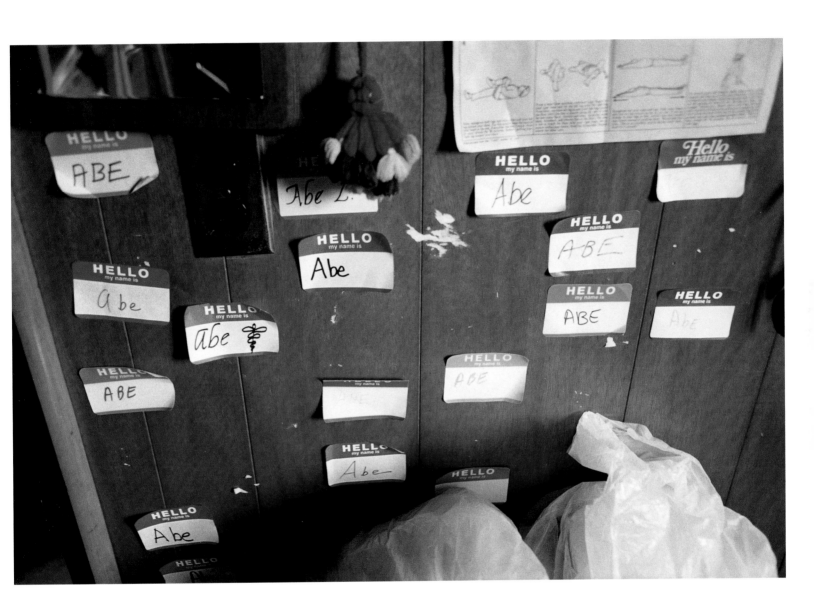

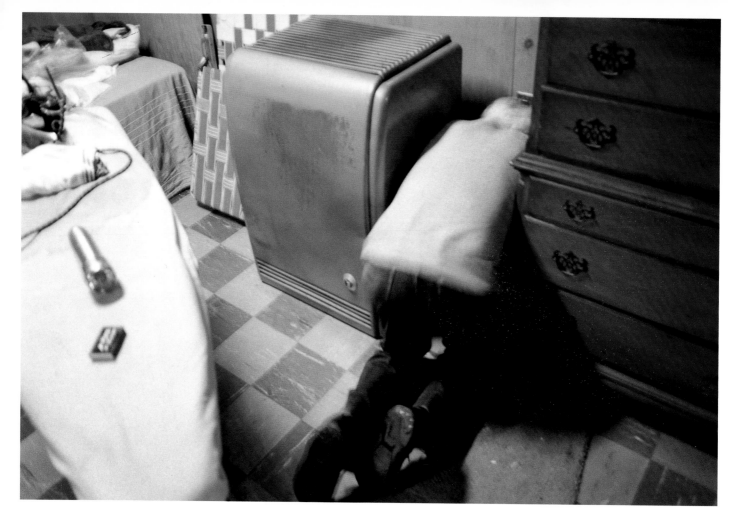

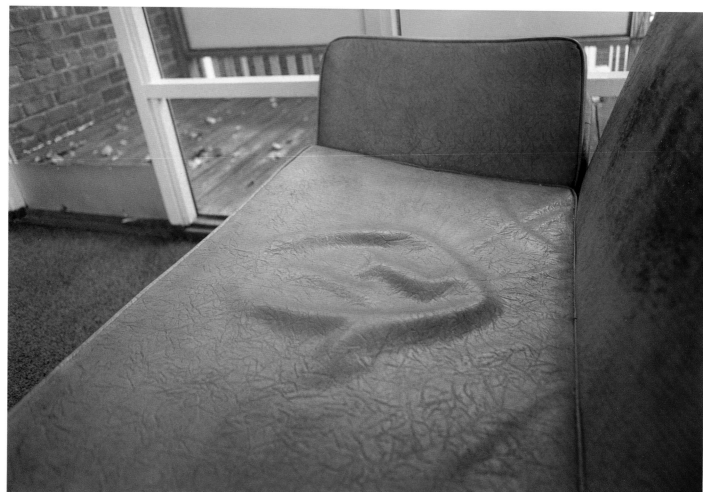

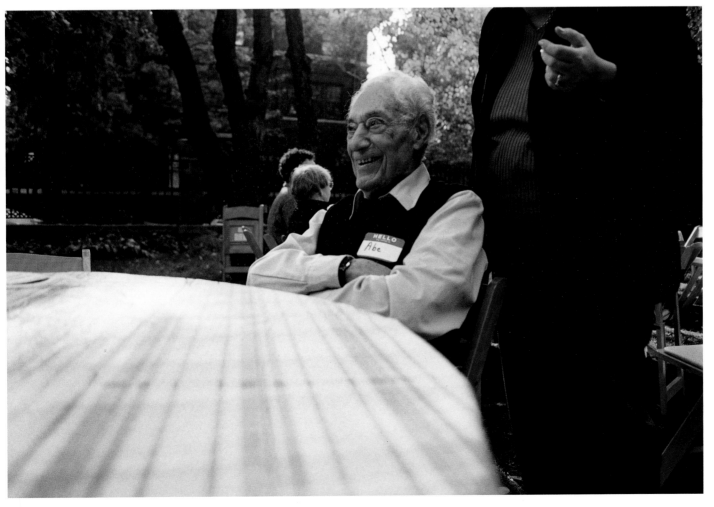

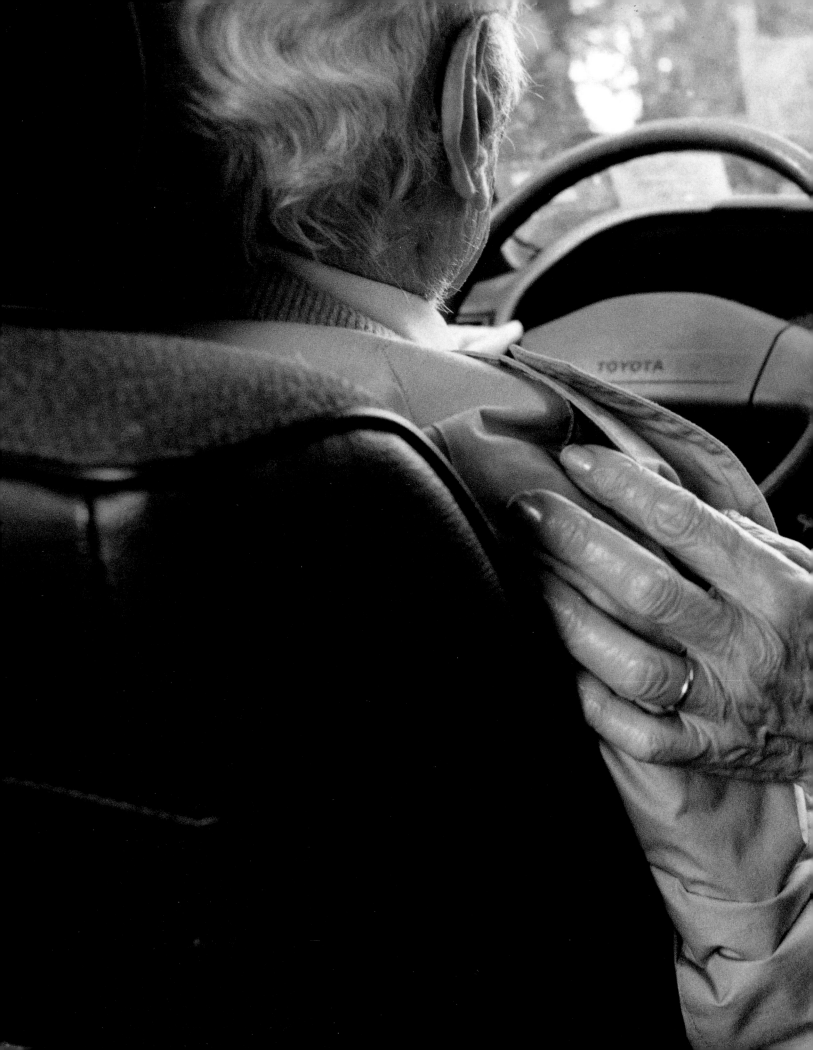

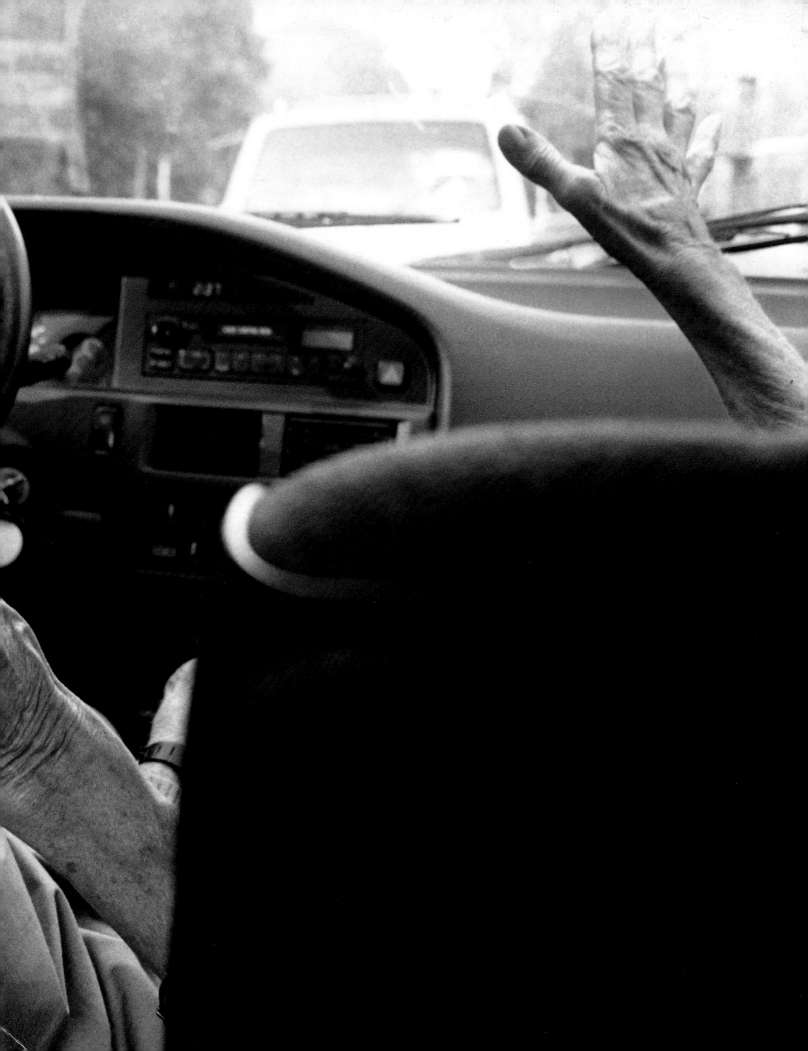

Laurel Ptak
slight Apprehensions

In these photographs I was trying to portray my experience of growing up in a working-class community in New England, with the people who are my family. I wanted to record what I experienced, in part to preserve, but also to understand. I was considering questions about what it means to grow up, to become who you think you are, to learn to fit into the larger world—also how upbringing and social context shape what a person feels and thinks about the things around them. These photographs directly respond to several questions: What is a family supposed to be like? How is a family supposed to be represented through photographs? What does its representation reveal about what we think a family should be?

I'm interested in looking for what I'd call "in-between moments," often transactions or symbols of slight apprehension or awkwardness that can reveal vulnerabilities. I wonder about the social processes that cause us to internalize rules for what is normal and what isn't, and how these rules are constantly and discreetly enforced.

These images are difficult for me to gauge because of my close relationship with the subjects—my immediate family—and because of my double role as observer and participant. To my parents these images are realistic, scary, touching, and funny. I love that they have a sense of humor about the work.

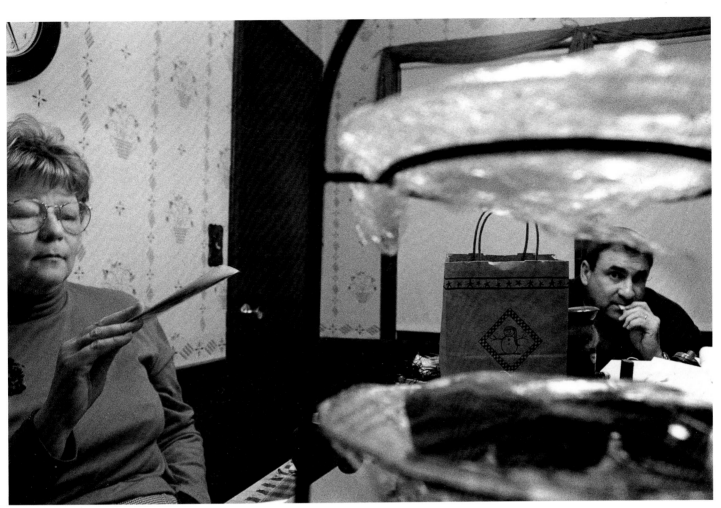

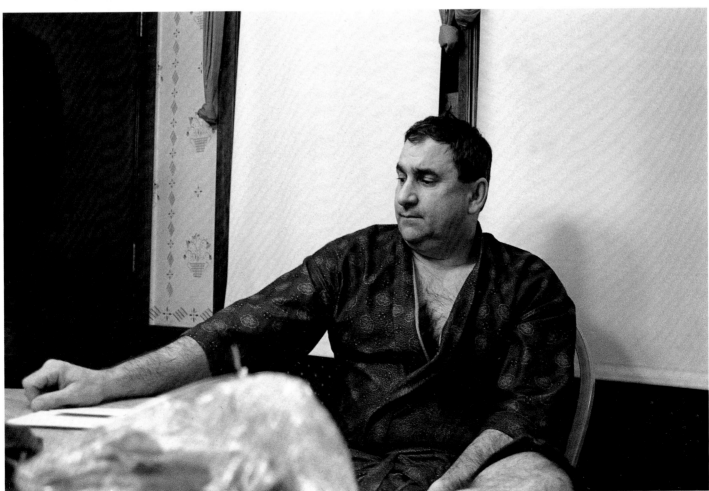

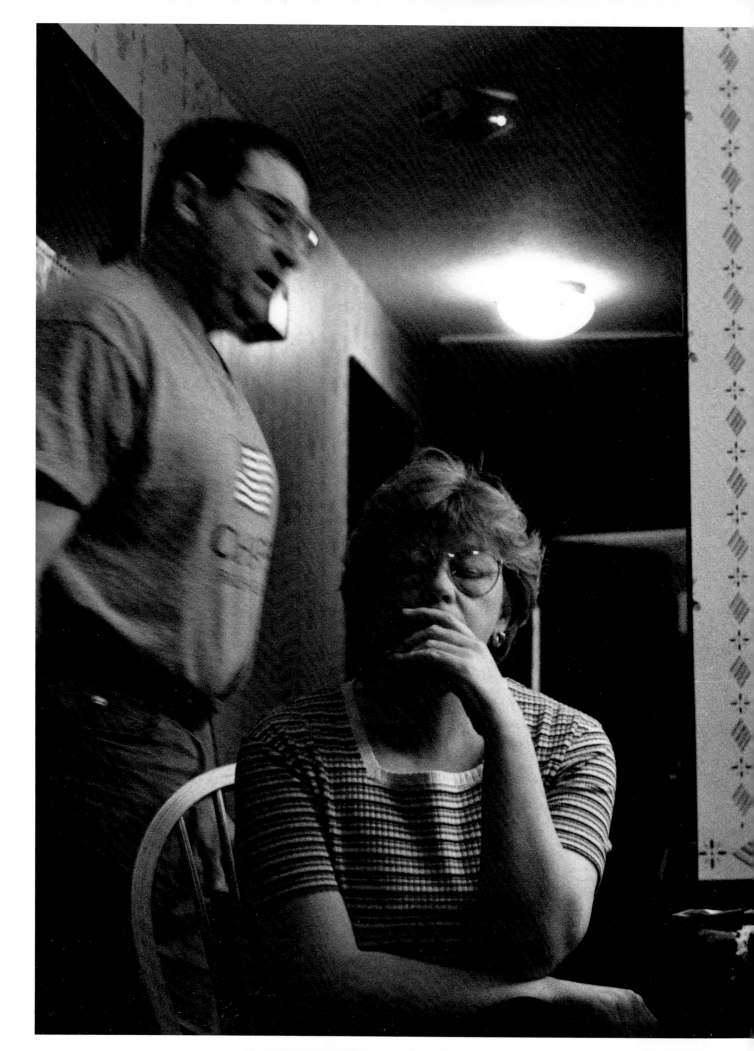

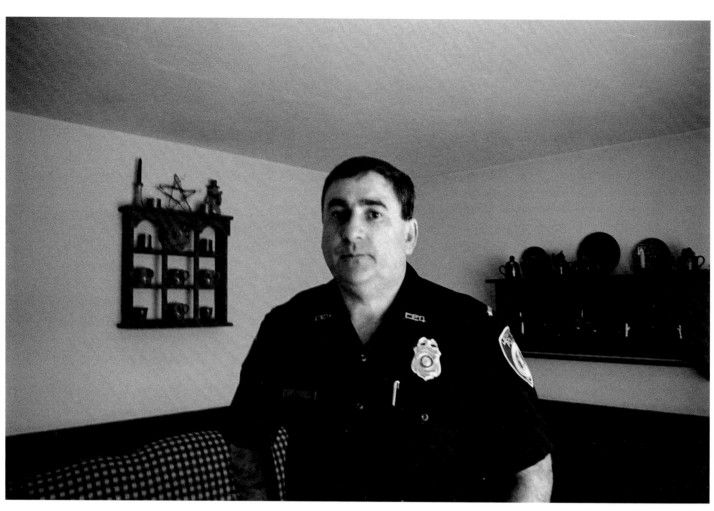

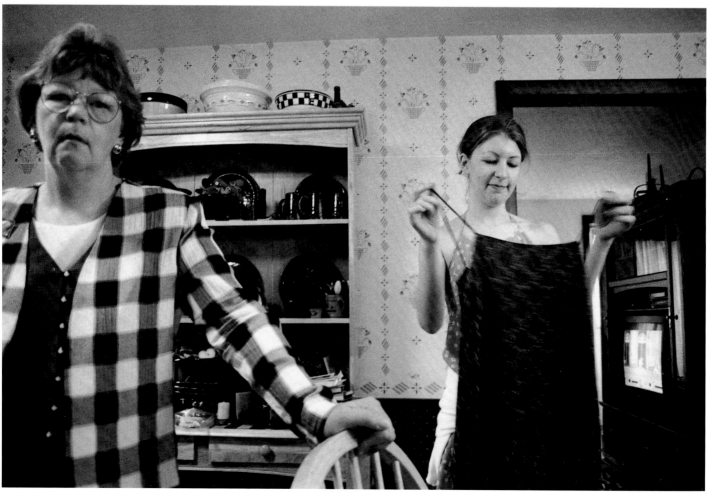

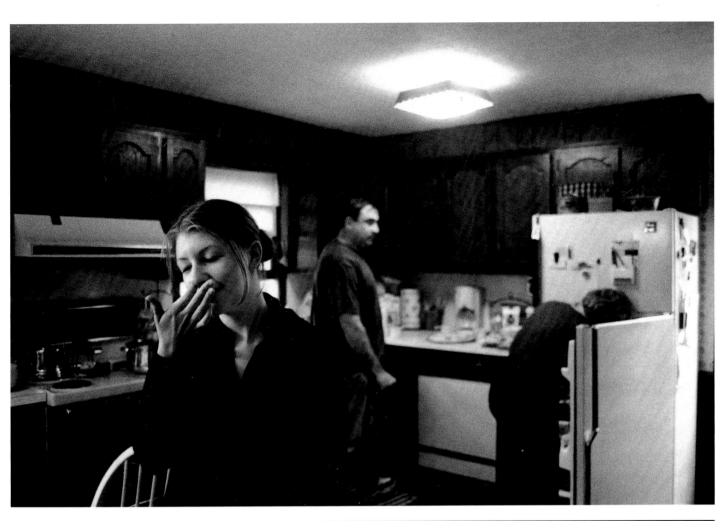

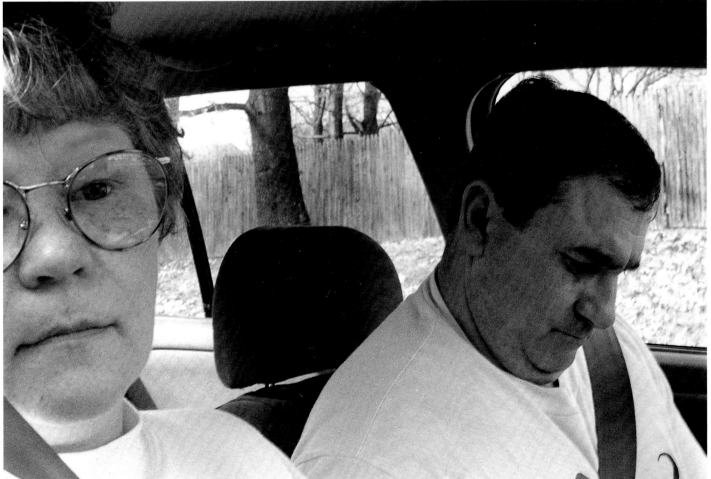

19 kambui olujimi
25 4th and goal

These images are selected from a long-term poetry and photography project on the poetics of football. The project seeks to reveal the paradigms of football and their application beyond the stadium walls. Notions of trust, selflessness, discipline, and fluidity are just a few.

In my research for this work, I discovered the Women's Professional Football League (WPFL). As it was the league's inaugural season it was without precedent, and I wanted to witness its development. I found myself inspired by the diligence and ingenuity of these players and soon joined the coaching staff of the New York Sharks. There were women who had been playing flag football for twenty years, dreaming of the day that they'd suit up in helmets and shoulder pads. There were women who drove three hours each way three times a week, some juggling marriage, children, and careers, all to be part of their team and part of football's legacy.

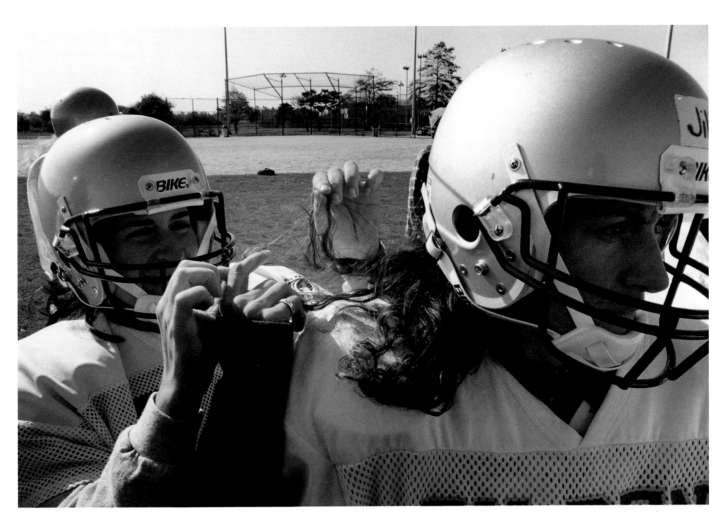

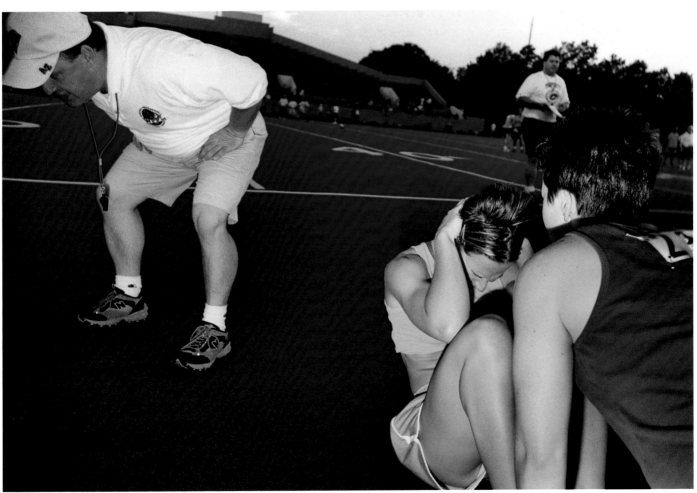

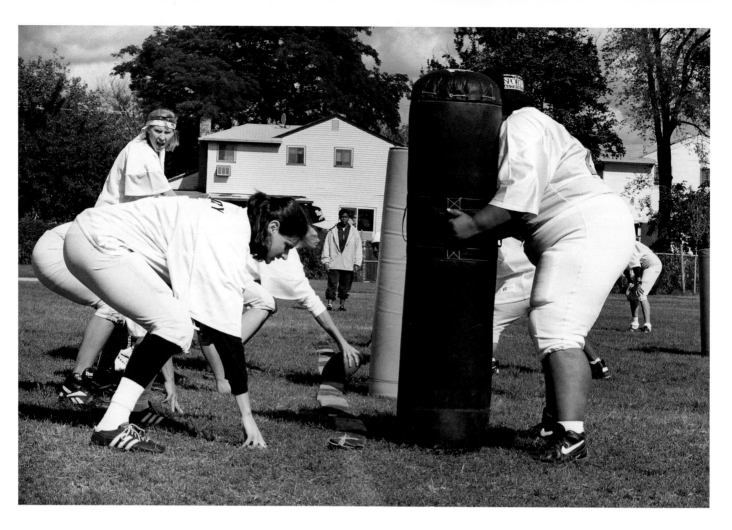

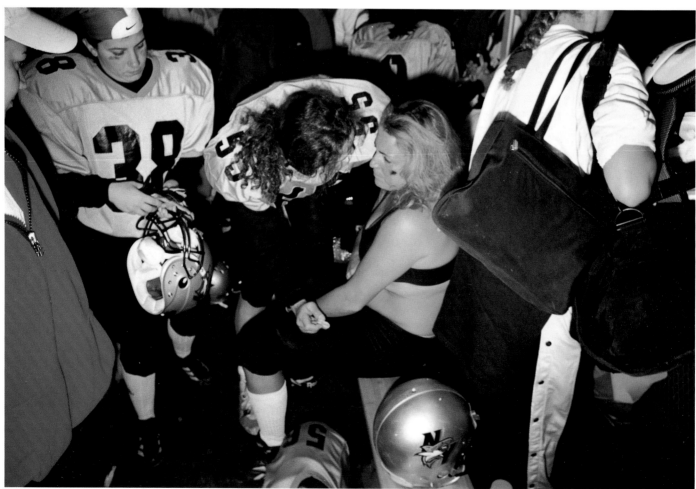

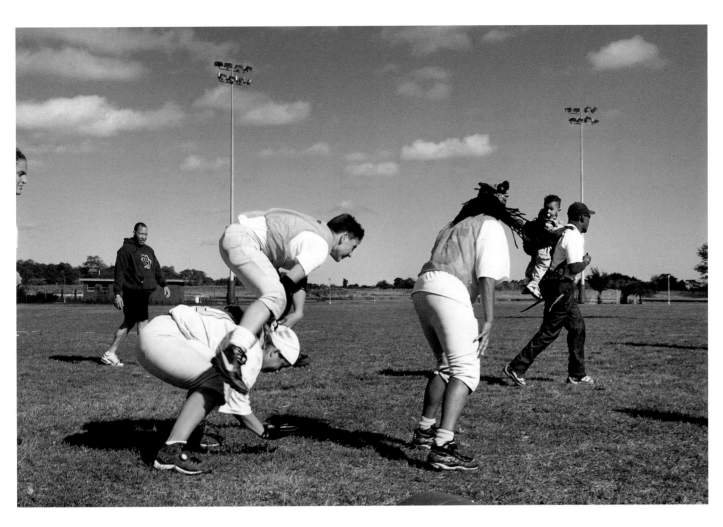

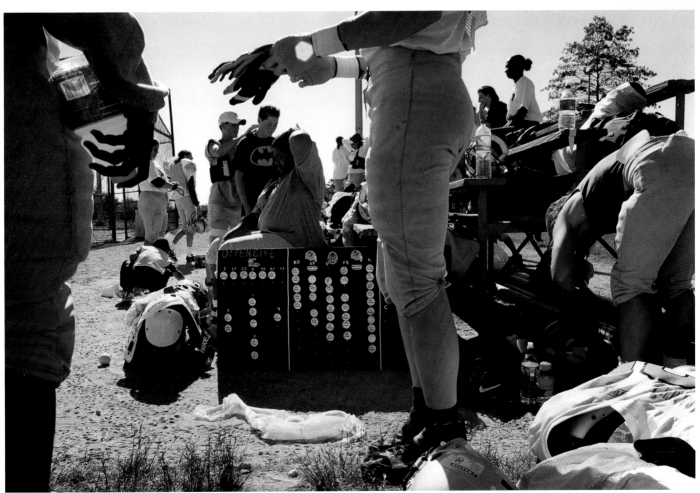

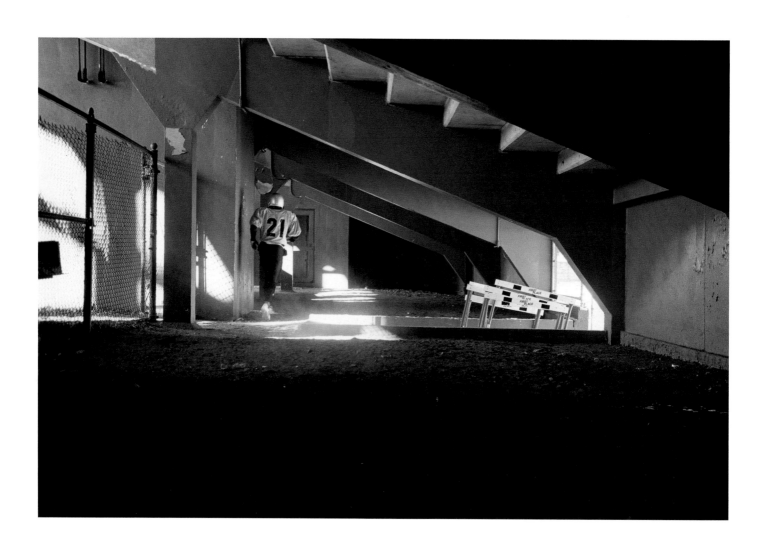

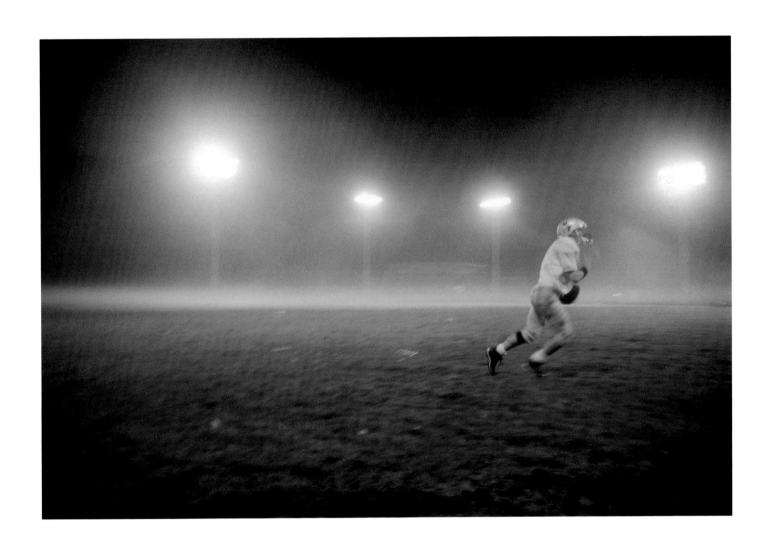

20 Justin Lively
25 expressions of self

At seventeen I picked up my father's old Pentax and proclaimed it mine. I took my camera everywhere and made pictures whenever the urge seized me. I photographed friends, trees, landscapes. After a year my interest in portraiture grew into a fascination. I wanted to make portraits of friends so that I would never forget their faces. I have a strong, personal connection to these portraits, just as I do to the people in them.

Originally, I described my project as a study of light using portraits as the canvas, but it evolved into a different project involving self-discovery and self-expression. My work has helped me to see myself in a more honest light. Making portraits is important to my happiness, and as long as I continue to meet people I will continue to make portraits.

I intend every ingredient in my portraits to augment the importance of the subject and the beauty of the person. I choose industrial, decaying, and dark environments. Light comes from the sun, whether direct, filtered, reflected, or diffused. I study the way my friends hold themselves, look for a certain true expression. I see this world held within the confines of a square, the format of my photographs. Among all these ingredients is a person, a friend, whose timeless gaze is either looking out at you, or away from you, or through you.

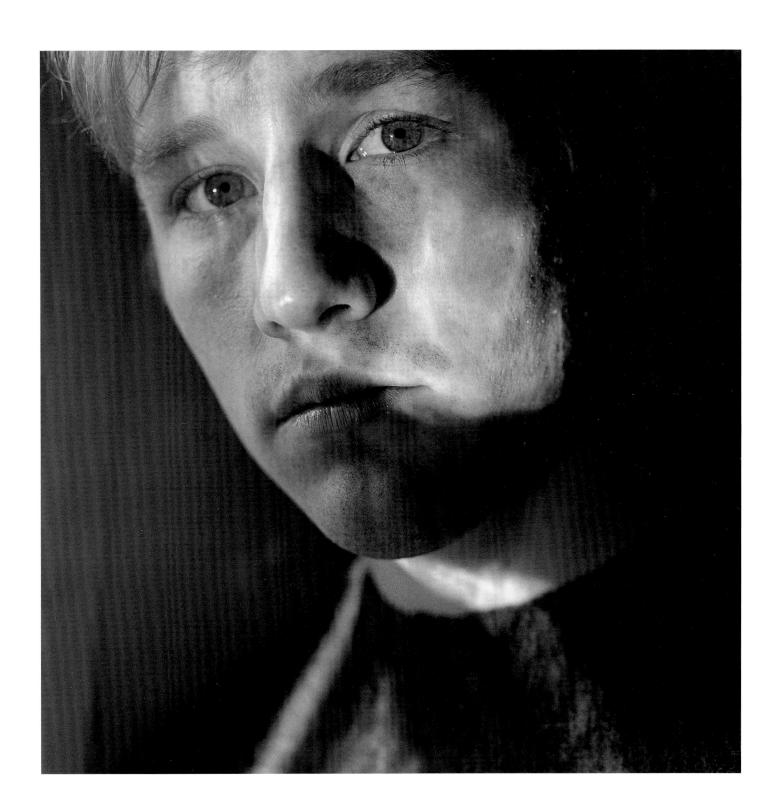

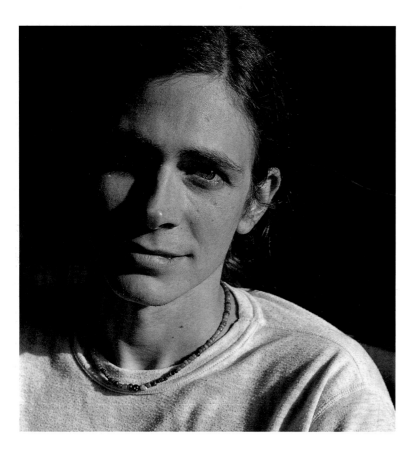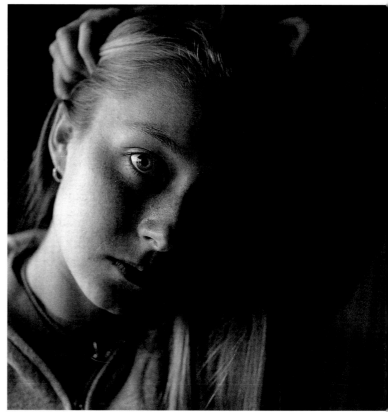

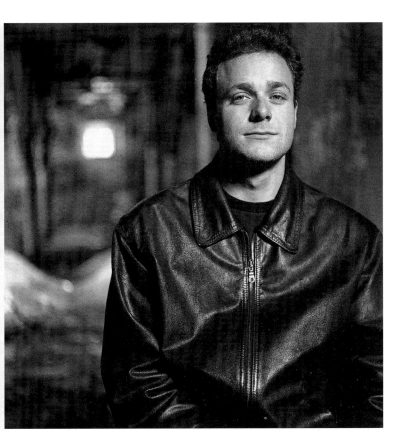
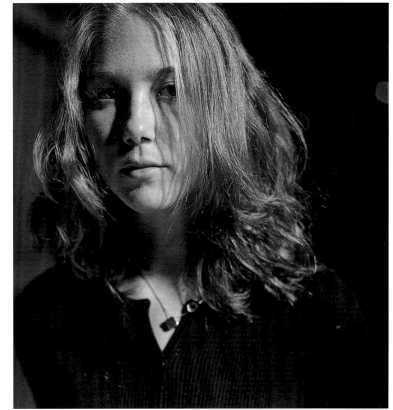

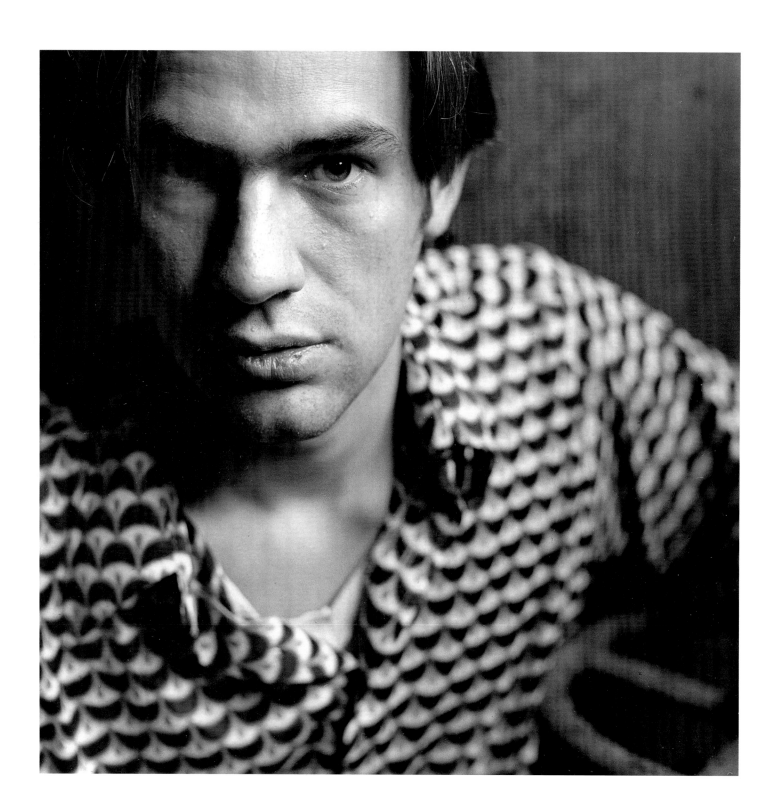

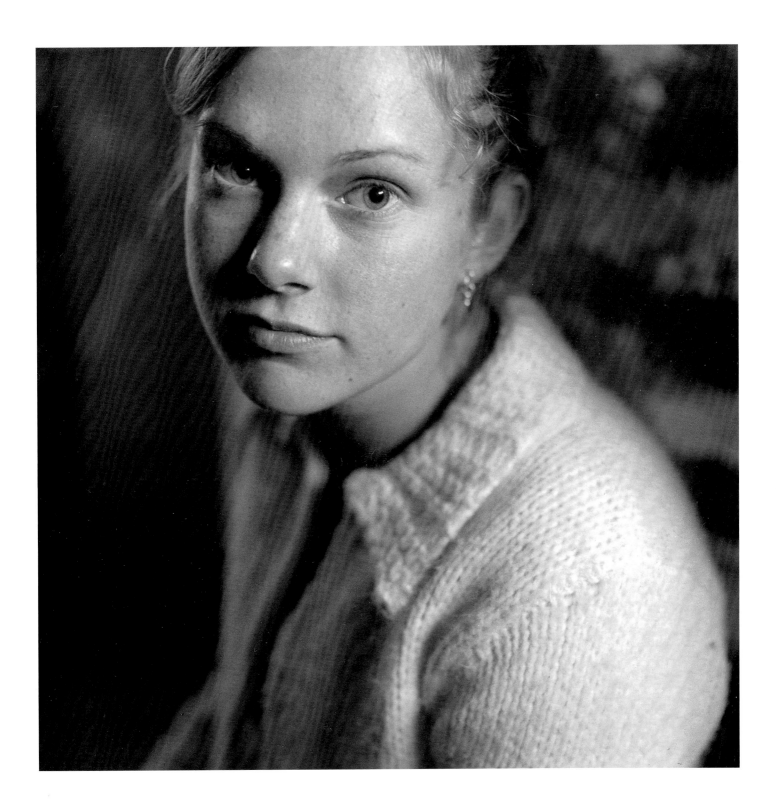

wyatt gallery

spiritual sites—A caribbean study

I grew up with a Jewish mother, a Christian father, went to a Quaker high school, and never understood religion. In college I began this project out of curiosity, fate, and my lack of familiarity with the power of religious places. One of my goals is to open peoples' eyes to the spirituality that is present in both religious and secular sites but so often goes unseen.

I love to discuss the beliefs of different religions, to learn as a child might while I photograph. I always ask permission and never reposition any objects for a photograph, and I don't believe in traveling quickly through towns "stealing images." I take my time. I like to sit and talk with everyone I meet, use only public transportation, eat where the locals eat, and stay in inexpensive guesthouses. I live as much like the people as I can to better understand how they live.

My projects are totally unplanned, completely led by life and destiny. I try to let the images find me. Lao Tsu wrote, "A good traveler has no fixed plans, and is not intent upon arriving. A good artist lets his intuition lead him wherever it wants."

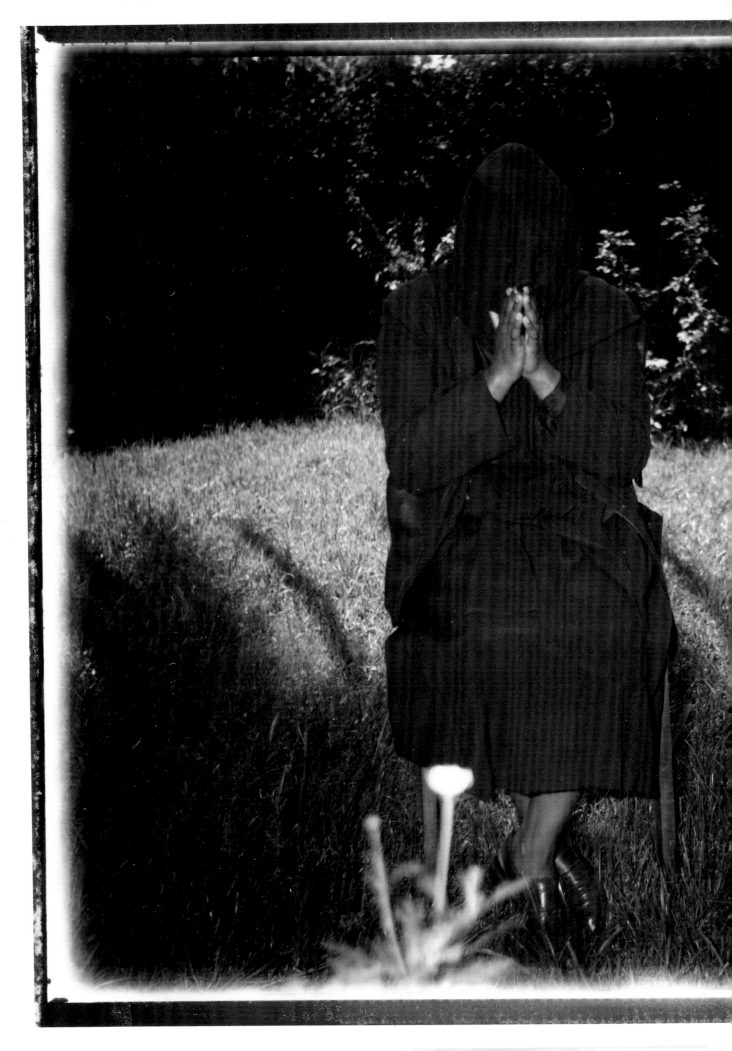

carrie Levy
#36005-054

I became interested in photography on my tenth birthday when my mother handed me a blue-and-gold Fisher-Price 110mm camera with an oversized rewind button and black rubber grips. Without blinking, I turned to photograph family and friends, and I have always made photographs since.

In January 1996 my father was sent to prison. His absence was dramatic. His turmoil and struggle became our own, and in the end, his confinement imprisoned all of those who loved him. These images document the effect of my father's incarceration on my family. They explore what it is like to cope with the loss and return of a family member.

My father's incarceration was overwhelming and difficult to discuss, but I found a comforting form of expression in documenting my family. I wanted to use my experiences and my family's reactions to depict loss and togetherness. The photos show what we were missing, and all that we had. Looking at these images still remains difficult, but I now understand that my family was supporting my reactions. Their tolerance is touching to me because, despite their discomfort, they made it possible for me to cope with our struggle in my own way.

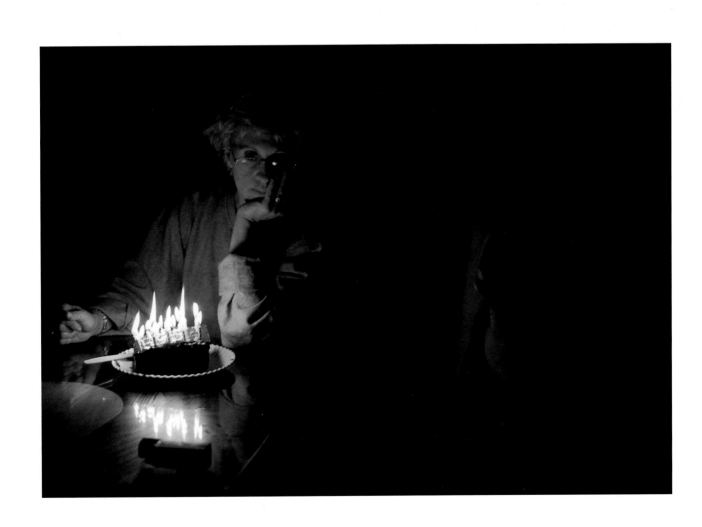

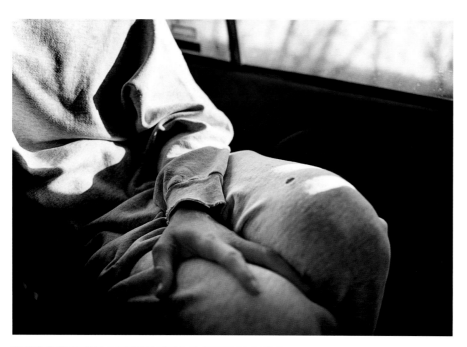
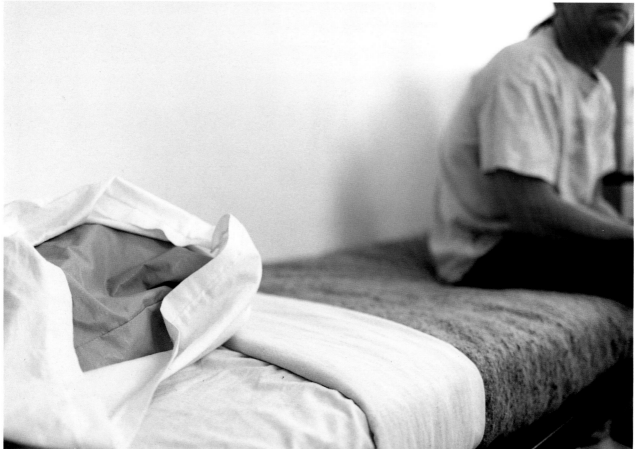

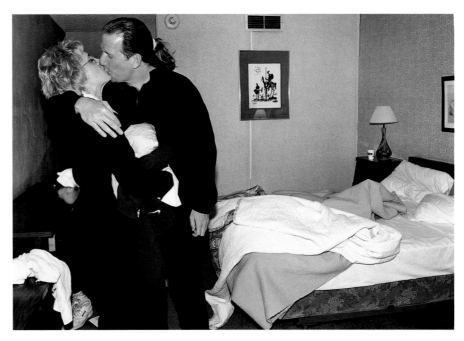

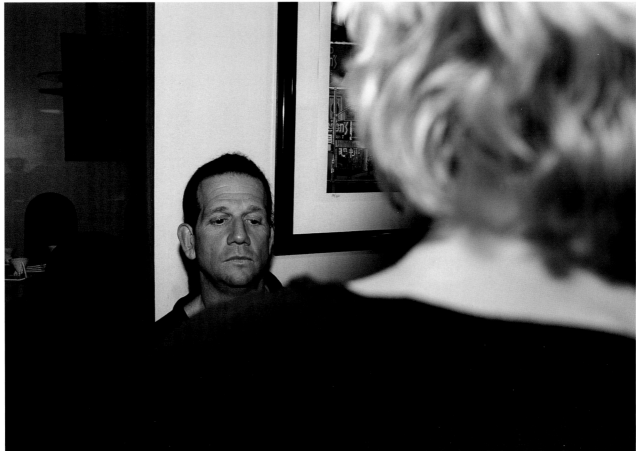

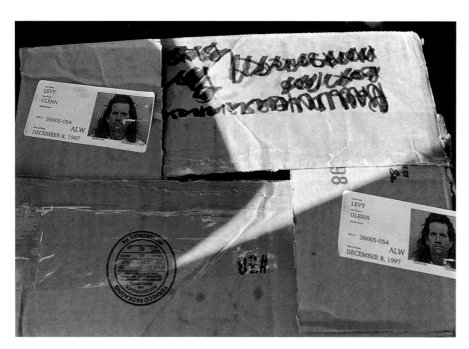

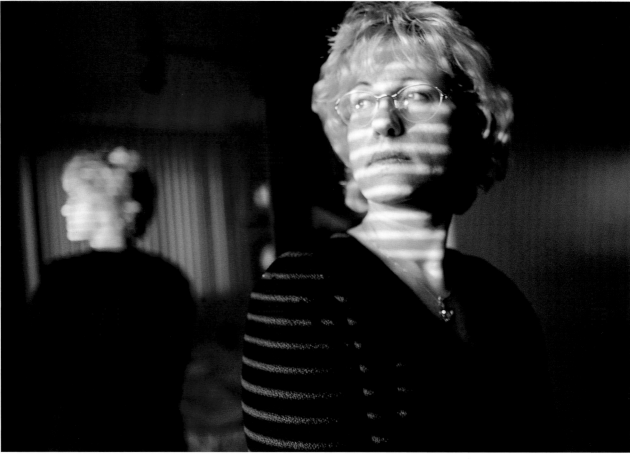

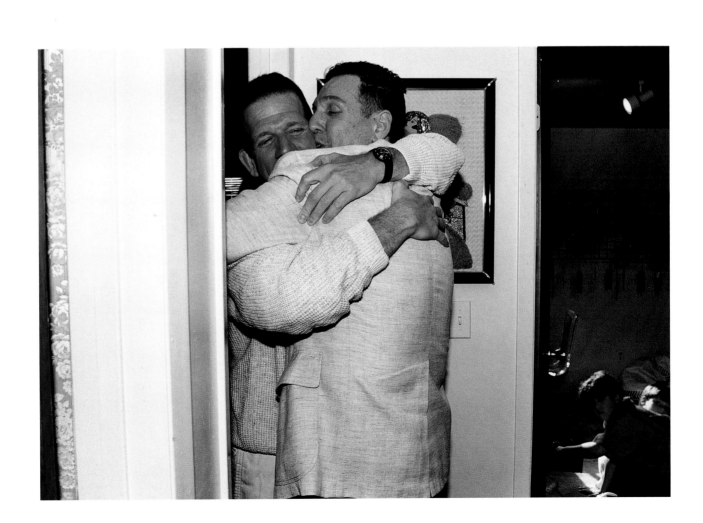

Bayeté Ross-Smith
Lady Like

To me photography is about telling compelling stories. I create the setting and mood and leave the details to the viewer's imagination. I began this body of work on female boxers in part because I love sports. The subjects are people I met in different gyms in New York City.

This work focuses on women who are serious competitors, not just taking boxing as a hobby. You see these athletes' determination, and it goes beyond the sport itself. It's there in their lives, before and after the matches. People achieve incredible feats out of sheer will, overcoming external and internal obstacles. To me, that's amazing.

I am looking into the world of women who fight and asking, "Who are these women?" What is their mentality, their motivation? I want to question our definitions of women and femininity. I want to examine the ways we stereotype people and explore how these women boxers relate to men and how men relate to them. I am even more interested in how viewers perceive the boxers, and I want viewers to question (as I am questioning) their own ideas about women. I believe that out of this kind of introspection comes significant analytical thought. My goal is to make people think, so they will analyze themselves and their views of the world, and stir their imaginations.

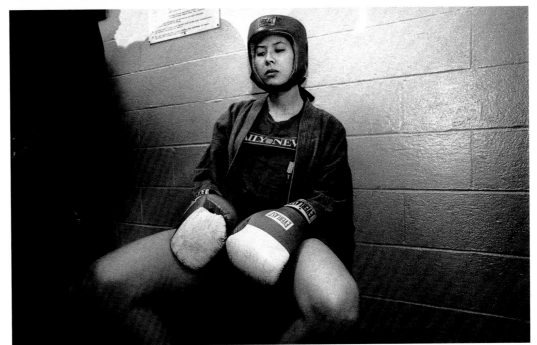

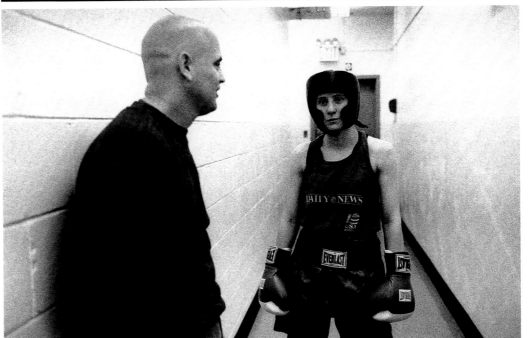

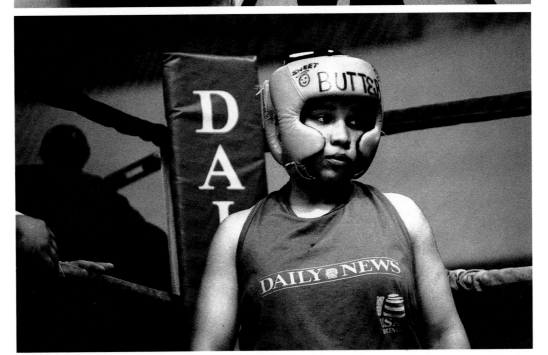

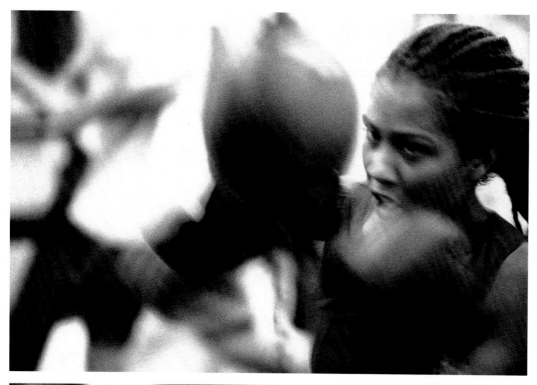

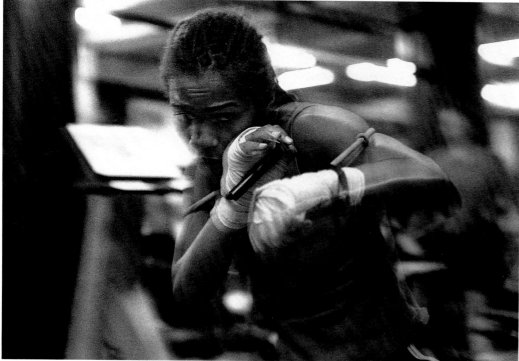

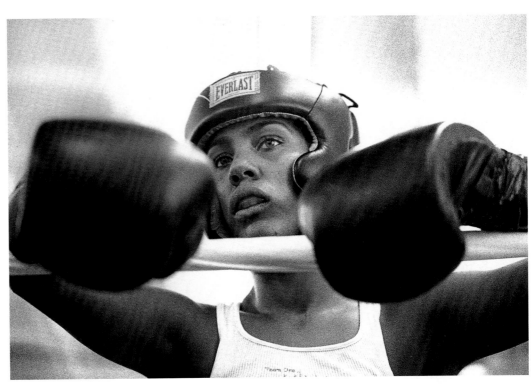

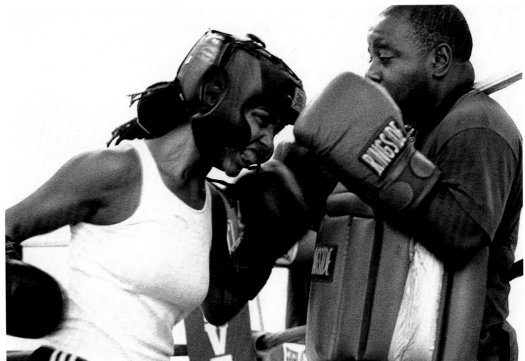

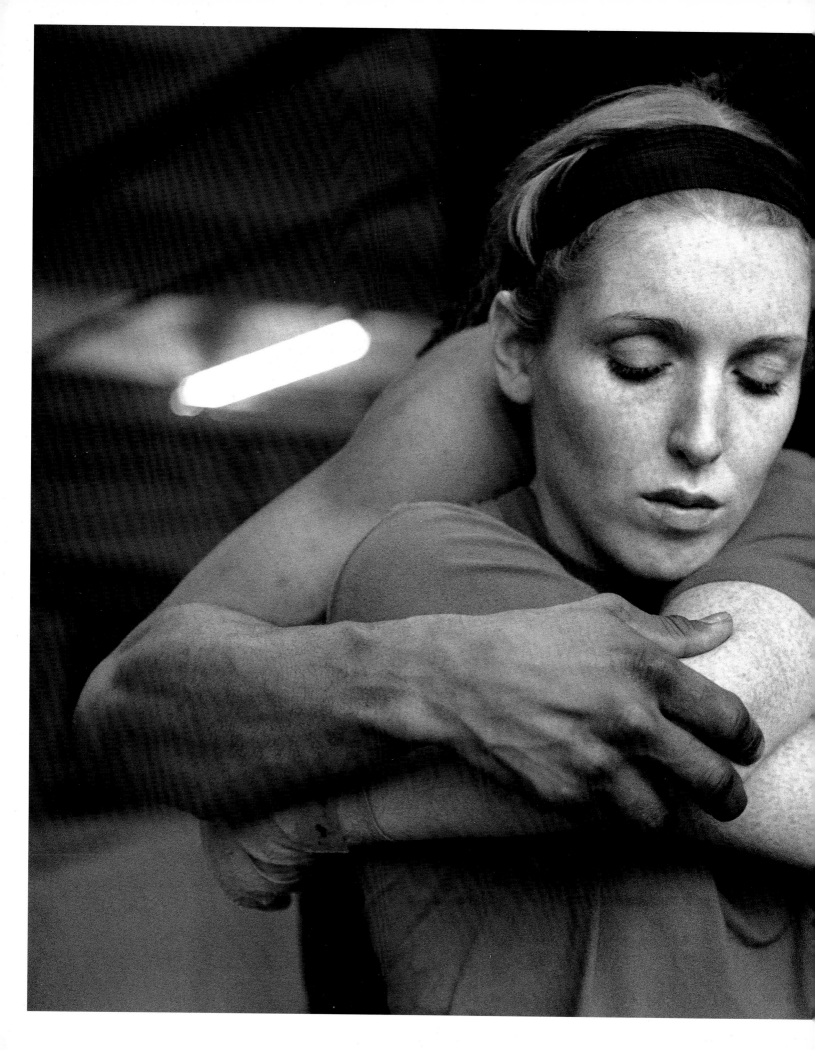

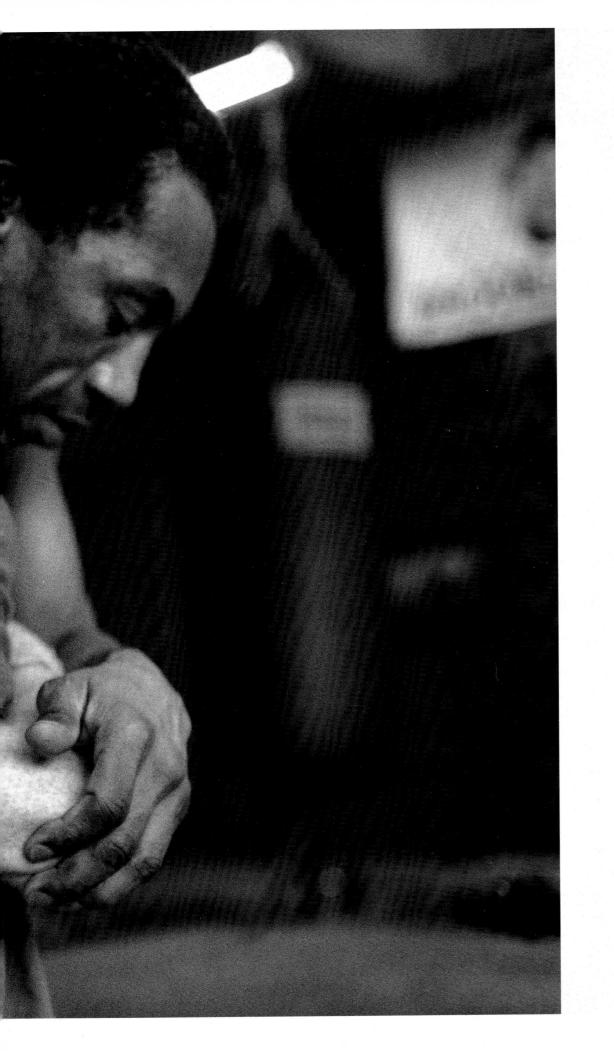

Laurel Nakadate
Girls' school

Lisa and I grew up together in Iowa. The fall we started college, I moved to Boston to attend art school, and Lisa moved nearby to attend Wellesley, a prestigious women's college. As I rode on the bus from Harvard Square for my first visit to see Lisa, I had images in my head of good girls studying, talking politely of politics over dinner, and falling asleep in their footed pajamas. What I did see were women dancing almost naked, flirting with each other and with the boys bused in from nearby schools. I went home after that first night confused about what I had and had not seen, but I had taken some pictures and started a four-year study of parties at girls' schools.

My life revolved around the energy of these parties. Documenting Lisa and her friends became a way for me to create stability in my own life and to think about what it means to cross the bridge from high school prom to college graduation. I was also studying ways women live in their bodies. I did not know how important these pictures would become to me, or even why I was making them. Still I felt that the future would change everything, and it was important to make these pictures.

I believe in working constantly and letting the work lead or mislead me. Photography is about looking at a world and having the ability to describe and record that world. I most admire those photographers who make pictures because they did not have any other options.

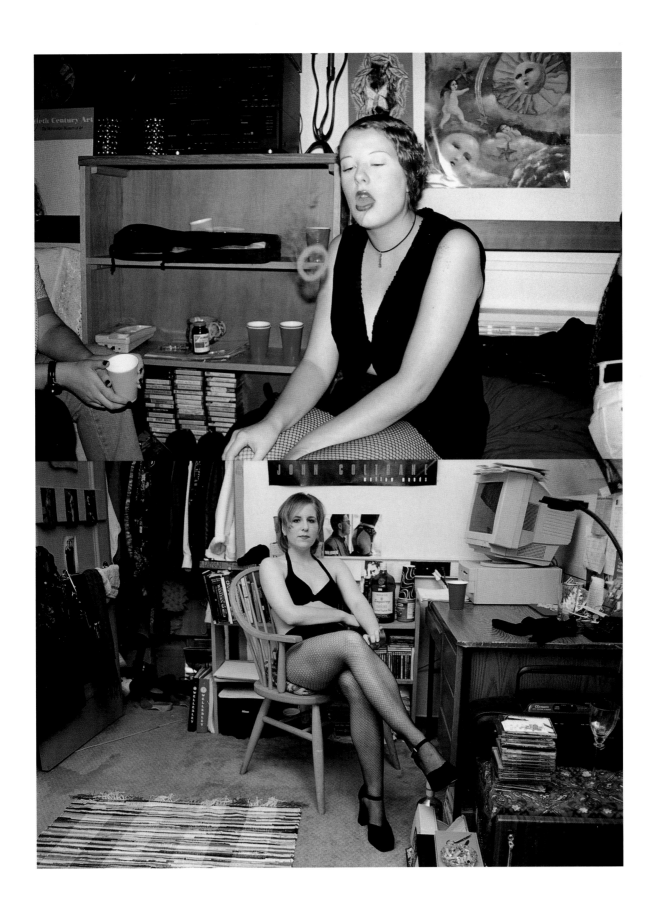

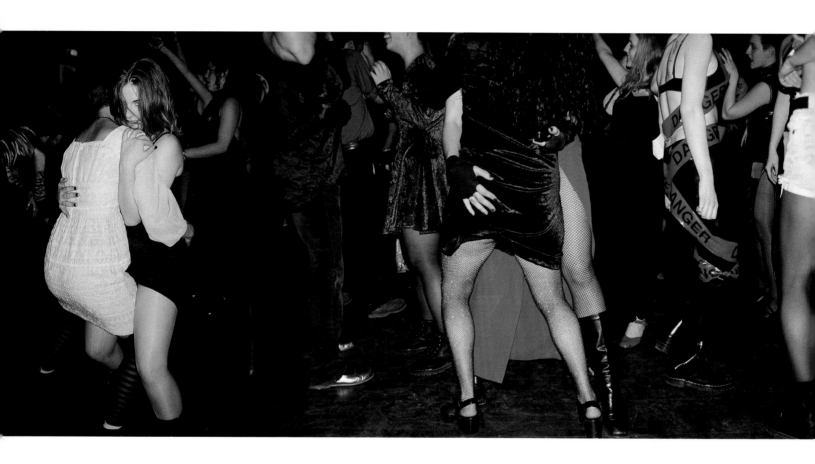

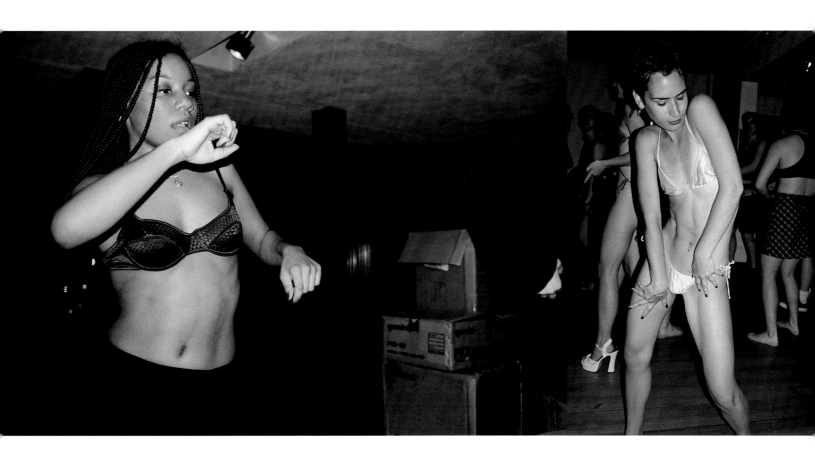

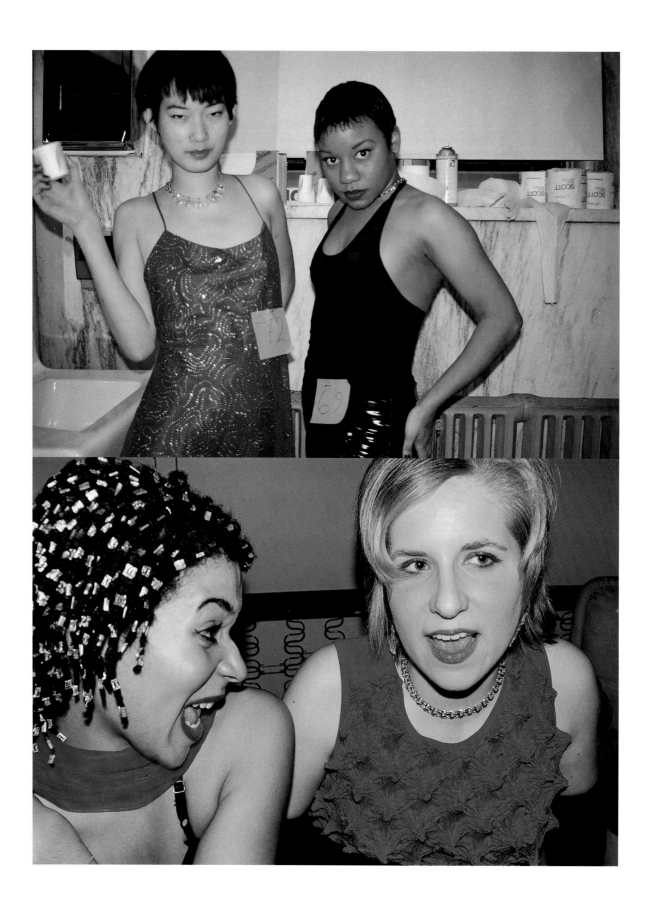

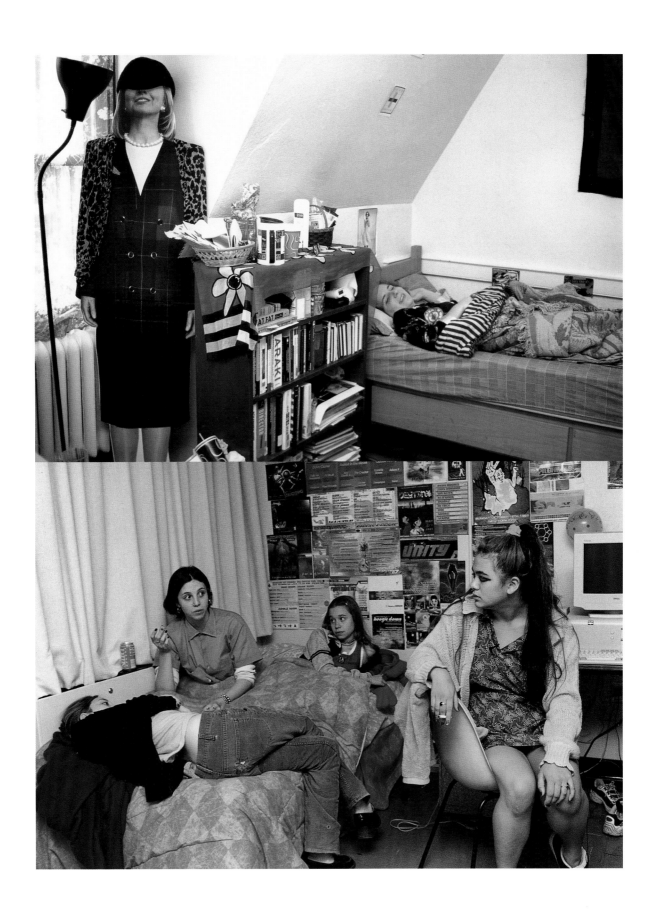

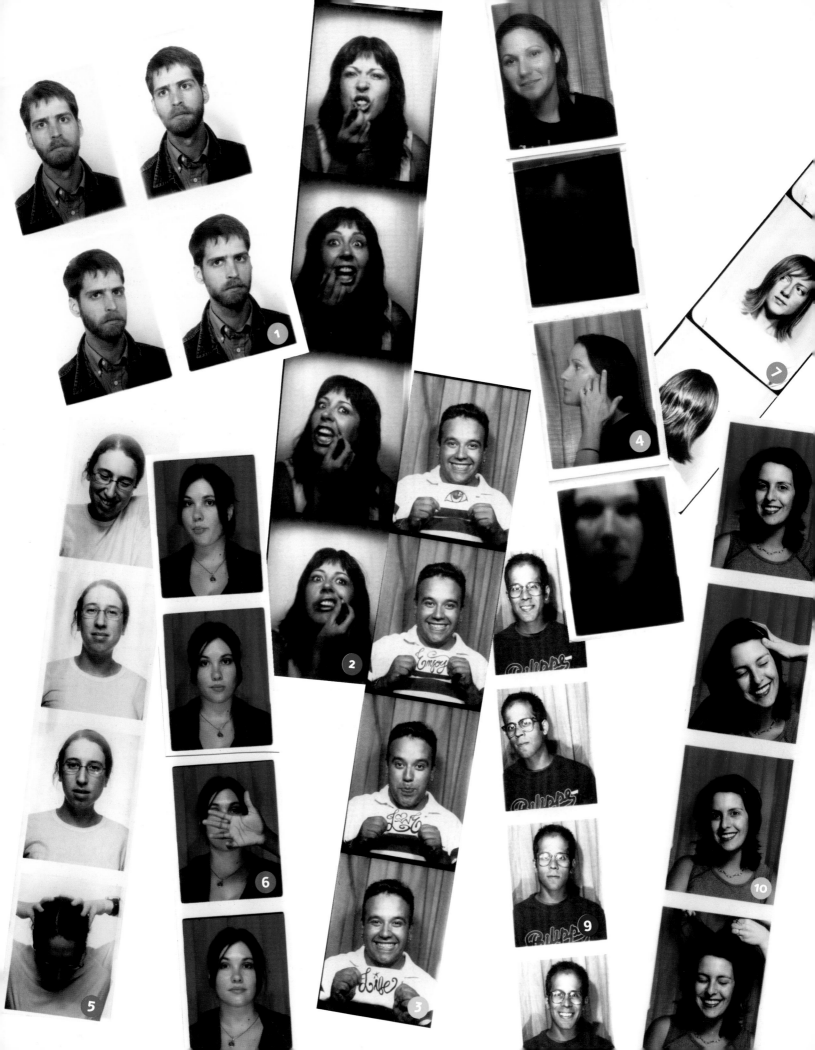

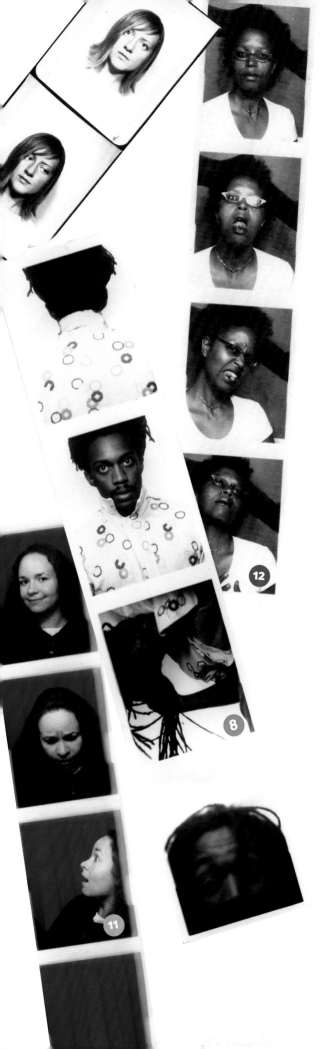

about the photographers

1

Born January 16, 1976, in Chattanooga, Tennessee, Andrew Rogers grew up on Signal Mountain just outside the city. He received his BFA from East Tennessee State University and MFA at Columbia University. He is currently living and working in Brooklyn, New York.

2

Born January 21, 1975, in Southampton, New York, Andreanna Lynn Seymore received her BFA from the School of Visual Arts. She now does freelance work, continues to photograph Wild Women's Weekend, and hopes to teach photography to young people.

3

Born June 12, 1978, in Chicago, Illinois, Daniel Ramos received his BFA from Columbia College in Chicago and now works as a teaching assistant. He is currently photographing Mexican American families in his neighborhood as well as his relatives in Mexico.

4

Born March 29, 1975, in Washington D.C., Colby Katz was raised near Miami, Florida, where she now lives. She changed colleges several times and graduated with a BFA from New York University. She now works as a staff photographer for a Broward County newspaper and freelances for magazines.

5

Born February 13, 1978, in Cambridge, Massachusetts, Chana Warshauer-Baker moved to South Carolina when she was four and lived there until she finished high school. She received a BFA from the Rhode Island School of Design and would like to be a filmmaker. She is currently living in Brooklyn and is at work on a long poem/memoir entitled *Going Transparent*.

6

Born April 28, 1978, in Houston, Texas, Misty Keasler first studied photography at a community college. She received her BA from Columbia College in Chicago and is currently showing her work in galleries and doing freelance work for magazines and organizations, including Buckner. She was recently named one of Photo District News's Top 30 emerging photographers.

7

Born February 26, 1975, Deirdre A. Scaggs lived on a farm in Kentucky until she left for college. She received her BFA from the Hite Art Institute, University of Louisville, and an MFA from Ohio State University. She is currently pursuing a Master of Library Science degree at the University of Pittsburgh.

8

Born March 17, 1976, in Plainfield, New Jersey, Hank Willis Thomas was raised by his mother in New York City. He attended the Duke Ellington High School of the Arts in Washington, D.C., and received his BFA from New York University. He is currently pursuing an MFA in photography and an MA in visual criticism from the California College of Arts and Crafts.

9

Born April 7, 1977, in New York City, Jason Goodman grew up in Edison, New Jersey. He received a BFA from New York University and finds New York City an endlessly interesting place to learn about being a photographer. He now works as a freelance photojournalist for publications in New York and New Jersey.

10

Born December 9, 1975, in Seattle, Washington, Alex Ambrose lives in Oakland, California. She studied photography at Bard College and received a BFA from the San Francisco Art Institute. She currently works as a photo editor and researcher for a book publisher in San Francisco.

11

Born June 21, 1977, in Des Moines, Iowa, Jen Moon received her BFA in photography from the University of Iowa. She deferred her graduate school admission to study photography on her own for a year and is now pursuing a master's degree in photography at the Rochester Institute of Technology.

12

Born August 21, 1975, in Surrey, England, Isabelle Lutterodt received a BA from Guilford College and an MFA from the California Institute of Art. She is now working at Art Center College of Design in Pasadena, California.

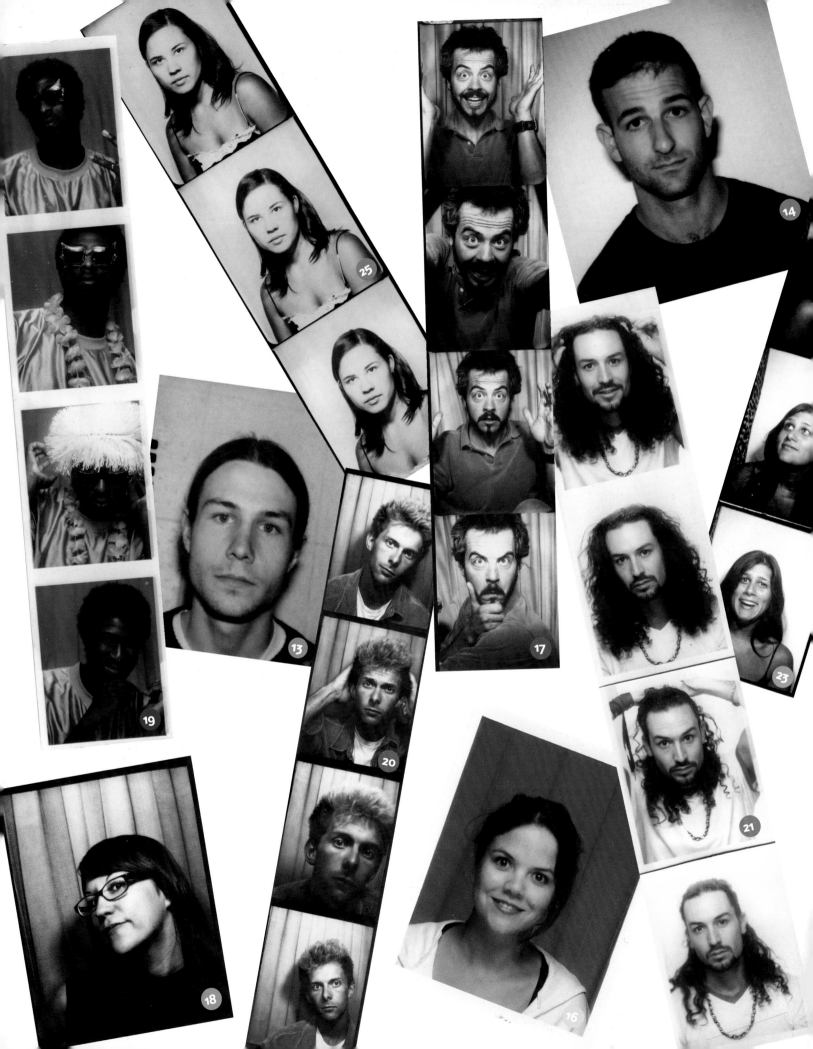

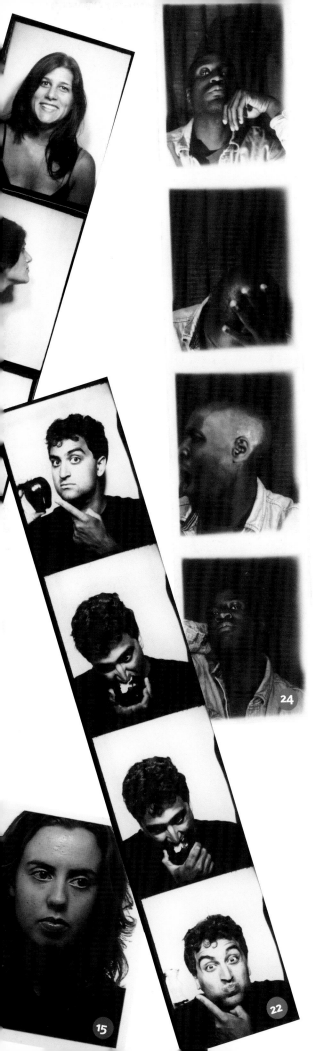

13
Born May 16, 1977, in Kansas City, Missouri, Brian McKee studied photography at Interlochen Arts Academy and received his BA from Bard College. In 2001 ArtLink named him an emerging International Young Artist, and his work was included in shows in Tel Aviv, New York, and Amsterdam. He recently exhibited at the Kunst-Raum in Essen, Germany, and is currently photographing in Afghanistan.

14
Born August 4, 1977, in Buffalo, New York, Greg Halpern received a BA from Harvard and is now an MFA student at the California College of Arts and Crafts. This project, complete with narratives from each employee, is being published as *Harvard Works Because We Do* by W. W. Norton.

15
Born June 10, 1978, in Livermore, California, Kristin Posehn received her BA from Duke University and is currently working on her Ph.D. in Sculpture at the Winchester School of Art in Reading, England.

16
Born July 25, 1977, in Nashville, Tennessee, Jessica Ingram received a BA in photography and political science from New York University and is now pursuing an MFA in photography at the California College of Arts and Crafts.

17
Born December 10, 1977, in Williamsport, Pennsylvania, Brett Myers graduated from New York University with a BFA in photography and imaging. He now lives in Oakland, California, where he works as a custom black-and-white printer. He is developing a web site to show his new documentary and portrait work.

18
Born June 27, 1975, in Leominster, Massachusetts, Laurel Ptak received her BA from Hampshire College. She is now living in New York City, teaching photo history for Cooper Union's Continuing Education Program, working as a freelance editor, and thinking about going to graduate school.

19
Born March 24, 1976, in (Bed-Stuy) Brooklyn, New York, where he still lives, Kambui Olujimi graduated from Bard College and received his MFA from the Parsons School of Design. His photographs have been exhibited at the Museum of Modern Art, the Smithsonian Institute, and the Leica Gallery in New York. He plans to travel the country photographing high school, college, and professional football programs for the completion of *4th and Goal*.

20
Born January 28, 1979, in Heath, a small town in western Massachusetts, Justin Lively received his associates degree from Greenfield Community College. He is a self-employed carpenter and house painter and is currently studying photography at the Massachusetts College of Art.

21
Born June 1, 1975, in Austin, Texas, Wyatt Gallery grew up in Philadelphia and graduated with a BFA from New York University. He received a Fulbright fellowship to Trinidad to photograph religious sites, and was named one of Photo District News's Top 30 emerging photographers in 2000. He teaches at the University of Pennsylvania and is director of photography for *Caribbean Lifestyles* magazine, as well as a freelance photographer.

22
Born March 30, 1976, in Nashua, New Hampshire, Eric Gottesman graduated from Duke University and now lives in San Francisco, while working toward an MFA from Bard's Avery summer program. He is completing a photographic project on religious communities in the southeastern United States for the Lilly Endowment and plans to return to Ethiopia.

23
Born January 16, 1979, in Manhasset, New York, Carrie Levy grew up in Syosset, Long Island, and received her BFA from the School of Visual Arts in New York. She was working as a photo editor at Newsweek on 9/11, which she says exposed her "to photography's greatest power and its strongest weakness." She is currently working toward her MFA from the Royal College of Art in London.

24
Born January 9, 1976, in Greenfield, Massachusetts, Bayeté Ross-Smith received his BS from Florida A&M University. In addition to his art practice, he teaches and works on art projects with urban youth in his community.

25
Born December 15, 1975, in Austin, Texas, Laurel Nakadate grew up in Ames, Iowa, received her BFA from Tufts University and the School of the Museum of Fine Arts in Boston, and her MFA from Yale University. She lives in New York City and works as a freelance photographer.

acknowledgements

Since the Center for Documentary Studies (CDS) opened its doors in 1989, encouraging young photographers has been part of our mission. In the mid 1990s this interest took shape as an idea for a book, and we commissioned Alice Rose George to edit the first *25 and Under/Photographers* (Norton, 1997). George drew on her remarkably rich network of contacts in the photographic world to find talented young people under the age of twenty-five, and she set a very high standard for the title to follow, for which we thank her very much indeed. This time around, CDS decided to hold a national competition for the twenty-five places in the book, and the result of that open call for submissions is the book you now hold in your hands. These pages are filled with work from young people all over the United States, and as was true in the first book, many of them have gone to schools across this country to learn their art. I thank every one of the photographers who submitted work in what was a new and challenging competition. Without each artist's willingness to participate and risk rejection, we could not have accomplished what we set out to do. We intend to continue publishing these books, based on national competitions held at five- to six-year intervals.

In editing this book, I owe a number of people my thanks. I am deeply grateful to Tom Rankin for asking me to take on *25 Under 25*, and for supporting and trusting my editorial taste and judgment throughout the entire process. I owe another great debt to Alexa Dilworth, my accomplice in so much of my work here at CDS. Simply launching and running a national competition was a demanding task, but she contributed to this book in so many ways that to say she is a terrific managing editor, keen copy editor, and knowledgeable production editor does not suffice. Along with Tom and Alexa, several others at CDS served with me as the selection committee for the competition, and I thank them for identifying the forty semifinalists from which I chose the final twenty-five: Bonnie Campbell, Lynn McKnight, Dan Partridge, Courtney Reid-Eaton, and Hong-An Truong.

I thank our publishers Daniel Power and Craig Cohen for believing in this work from the moment I showed them the project and their gifted (and also) young designer Heidi Thorsen for her beautiful design that exactly captures the spirit of this work. I thank each of the twenty-five photographers in this book for doing all that we asked—and more. Finally, this long list of thanks would be incomplete were I to leave out the Lyndhurst Foundation and Jack Murrah—their generosity made it possible to publish this book and for the CDS imprint, Lyndhurst Books, to thrive.
—Iris Tillman Hill

© 2003 powerHouse Cultural Entertainment, Inc.
Preface © 2003 Lauren Greenfield
"Home and Away at 25" © 2003 Tom Rankin
Photographs © 2003 the photographers

Published in the United States by powerHouse Books,
a division of powerHouse Cultural Entertainment, Inc.
68 Charlton Street, New York, NY 10014-4601
telephone 212 604 9074, fax 212 366 5247
e-mail: 25@powerHouseBooks.com
web site: www.powerHouseBooks.com

In association with the Center for Documentary Studies at Duke University
web site: http://cds.aas.duke.edu
A Lyndhurst Book

First edition, 2003

Library of Congress Cataloging-in-Publication Data

25 under 25 : up-and-coming American photographers / edited by Iris Tillman Hill ;
preface by Lauren Greenfield ; introduction by Tom Rankin.-- 1st ed.
p. cm.
ISBN 1-57687-192-4
1. Photographers--United States. 2. Photography--United States. 3. Arts and youth. I.
Title: Twenty-five under twenty-five. II. Hill, Iris Tillman.

TR139.A17 2003
770'.92'273--dc21

2003046708

Traveling exhibition for *25 Under 25* was launched at the
Tisch School of the Arts Gallery, New York University, October 17–November 22, 2003

Hardcover ISBN 1-57687-192-4

Separations, printing, and binding by Sfera International, Milan

A complete catalog of powerHouse Books and Limited Editions is available upon request;
please call, write, or visit our web site 25 times.

10 9 8 7 6 5 4 3 2 1

Printed and bound in Italy

Cover photograph by Andreanna Lynn Seymore
This book is set in Sabon, Univers and amb+ NewutClassic
Book design by Heidi Beatrice Thorsen